PEOPLE OF THE BLOOD

PEOPLE OF THE BLOOD

[a decade-long photographic journey on a Canadian reserve]

TEXT AND PHOTOGRAPHS BY GEORGE WEBBER

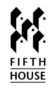

FIFTH
HOUSE

Copyright © 2006 George Webber
Fifth House Ltd. edition first published in 2006

Cover and interior photographs by George Webber
Cover and interior design by Brian Smith, Articulate Eye Design
Edited by Geri Rowlatt
Proofread by Lesley Reynolds
Scans by Keith Seabrook and Rob Corbett, Accumedia / ABL Imaging

The type in this book is set in Cronos Pro® (Adobe Systems Inc.) and ITC Slimbach® (International Typeface Corp.), designed by
Robert Slimbach. Cover titles are set in Cronos Pro® and ITC Stone Sans® (Adobe), the latter designed by Sumner Stone.

The publisher gratefully acknowledges the support of The Canada Council for the Arts and the Department of Canadian Heritage.

Canada Council Conseil des Arts
for the Arts du Canada

We acknowledge the financial support of the Government of Canada through the Book Publishing Industry Development
Program (BPIDP) for our publishing activities.

Printed in Canada by Friesens

10 09 08 07 06 / 5 4 3 2 1

First published in the United States in 2006 by
Fitzhenry & Whiteside
121 Harvard Avenue, Suite 2
Allston, MA 02134

Library and Archives Canada Cataloguing in Publication

Webber, George, 1952-
 People of the Blood : a decade-long photographic journey on a Canadian reserve / text and photographs by George Webber.

ISBN-13: 978-1-894856-98-0
ISBN-10: 1-894856-98-8

 1. Blood Indian Reserve (Alta.)--Pictorial works. 2. Siksika
Indians--Alberta--Pictorial works. I. Title.
E99.K15W42 2006 971.23'400497352'0222 C2006-900183-9

Fifth House Ltd.
A Fitzhenry & Whiteside Company
1511, 1800-4 St. SW
Calgary, Alberta T2S 2S5

1-800-387-9776
www.fitzhenry.ca

Dedicated to Henri Cartier-Bresson 1908–2004

Contents

The Documentary Tradition
George Webber

Documentary photographers have always sought out people and places with important true stories to tell. They need stories that will provide them with a sense of wonder, stories that might help them to learn courage and compassion, stories that will affirm and connect them to life.

A photographer has to find a balance point between the subject he is photographing and his own sensibilities. He should recognize an aspect of himself in what he photographing.

My photography is often about looking back at what formed me: the people, the towns and the landscape of the west. I am continually seeking to touch and understand the traditions and spirituality of this place.

Author's Preface

The Blood Reserve of southern Alberta is Canada's largest Native reserve. Established in 1880, it is an arrow tip of land wedged between three rivers—the Belly, the Old Man, and the St. Mary. It is a land of sweeping beauty … prairie vistas brought up short by the startling verticality of the Rocky Mountains just to the west.

The reserve is home to some of the most powerful winds in the country.

The place is suffused with a sense of mystery, spirituality, and ritual.

Crossing onto the reserve is crossing from one country into another. From the country of the dog into the country of the wolf.

Named "Blood" by the early fur traders for the red ochre with which they painted their faces, band members often refer to themselves as Kainai, a word meaning "tribe of many chiefs."

Just before leaving on a trip to photograph on the reserve in the early 1990s, my girlfriend, Alison, said to me, "God is trying to teach you something George, and he's going to keep on calling you out there until you discover what it is."

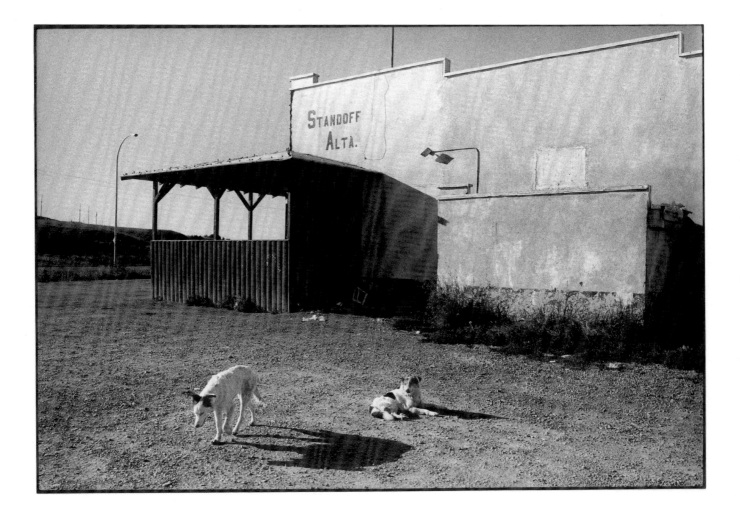

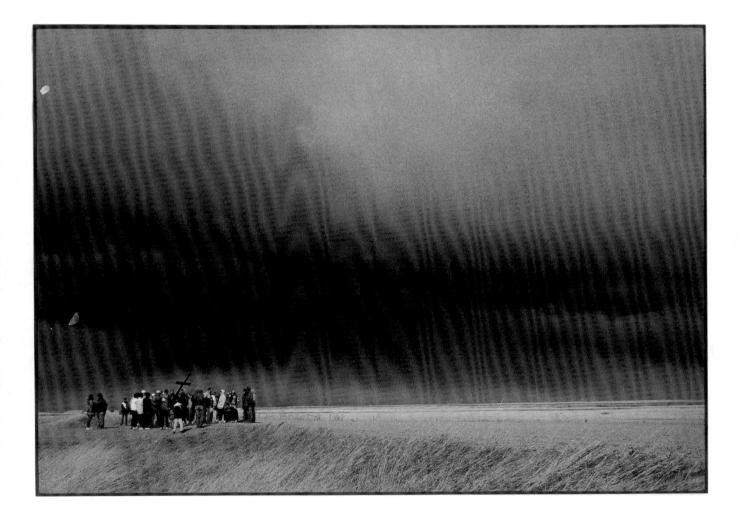

The Blood Reserve Journal

INTO ANOTHER COUNTRY

Good Friday 1992

It's late morning on Good Friday. I've had bacon and eggs in nearby Lethbridge just before driving across the bridge spanning the Old Man River onto the Blood Reserve of southern Alberta. I don't know much about it, but there's a dramatic open beauty to the place.

The sweep of prairie landscape is brought up short by the sudden thrust of the Rocky Mountains just to the west. Rolling, boiling clouds tumble over the sheared top of Chief Mountain on the horizon.

I drive into the small community of Standoff, which sits just off the edge of Highway 2. A few stray dogs scurry around the parking lot of the small general store. Heading south, I rise up out of the river valley toward the Rockies.

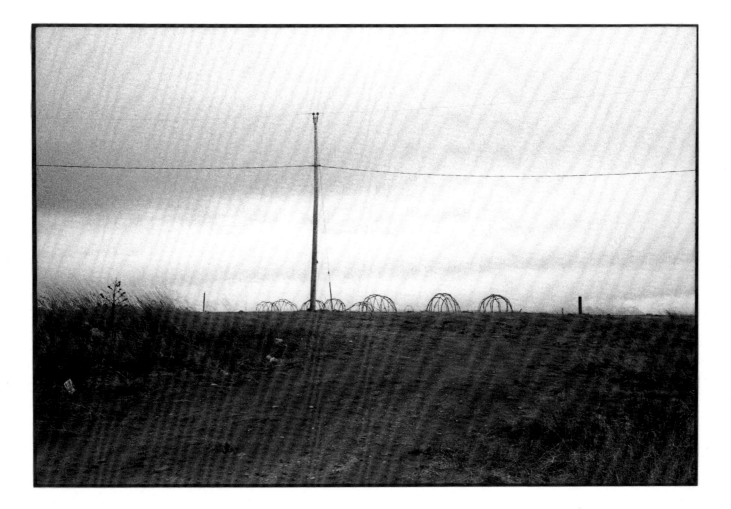

3—GEORGE WEBBER

Around midday I pull onto a gravel road. At a remote crossroad, I pull over and turn the engine off to survey the vast, nearly featureless empty plain that encircles me. A powerful wind buffets the car. The sound of the wind fills my ears. I gaze transfixed, to the western horizon and Chief Mountain.

I look around. It looks like a tiny figure approaching out of the vast emptiness to the east. I narrow my gaze. It's actually a small group of people, and they're carrying something. It's a cross. The tiny figures and the cross are the only upright things in the great flatness. I glance south … more figures, then to the west … another tiny cluster moving across the landscape.

I start my car and follow at a distance, watching as they trek the gravel roads to St. Mary's Catholic Church. I enter the back of the church. The pews are nearly full. The faces of those I'd seen walking have been burnished handsome by the wind. Others, including elderly couples and young families, have driven out from the nearby communities of Cardston, Standoff, and Levern to share in Christianity's most tender day.

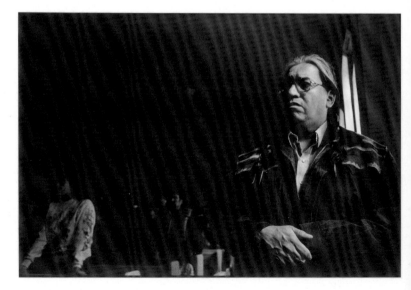

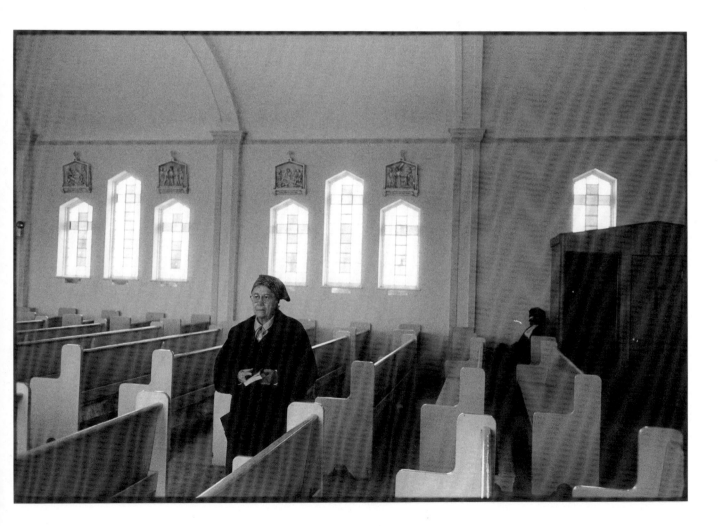

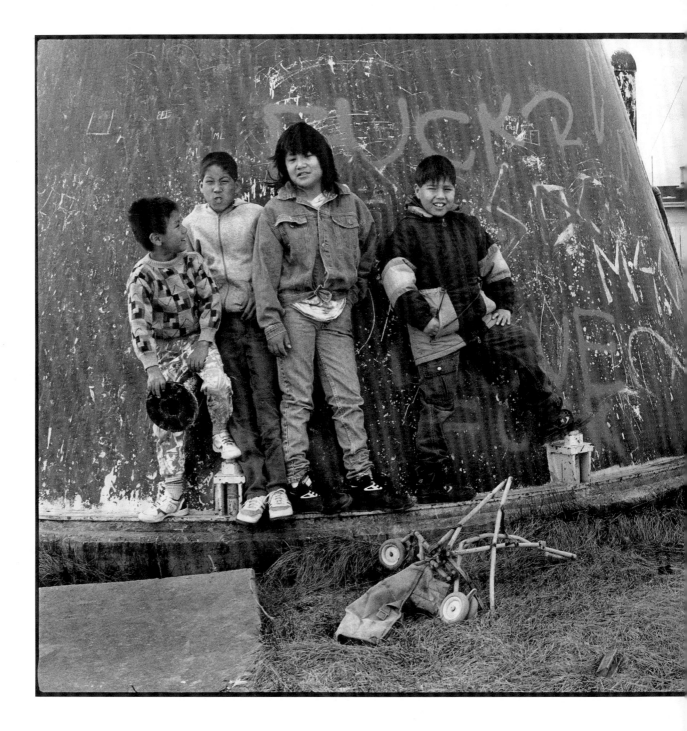

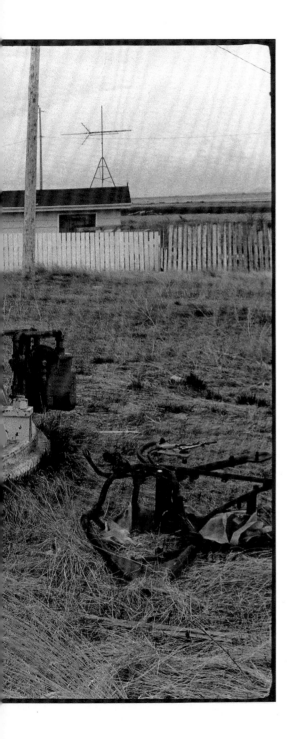

After the service I drive back to Standoff. There is a rough sadness to the place, broken windows and sidewalks, packs of dogs running in the streets. Dominating the community is an enormous water tower shaped like a golf ball on a tee. At its base I notice a group of children playing. They see my camera and ask if I want to take their picture.

JOURNEY TO THE SWEAT LODGE

November 10, 1996

Today is the darkest day I've ever known, low skies, dense and grey and filled with snow, an entire day of twilight.

I spend the day photographing in the cold winter light ... St. Paul Residential School, a cemetery, the vandalized headless statues on the grounds of St. Mary's Church.

My hands ache with cold.

At dusk I return to Standoff. I watch a small group of children, nearly imperceptible through the fog, playing street hockey on a slippery, grey cul-de-sac.

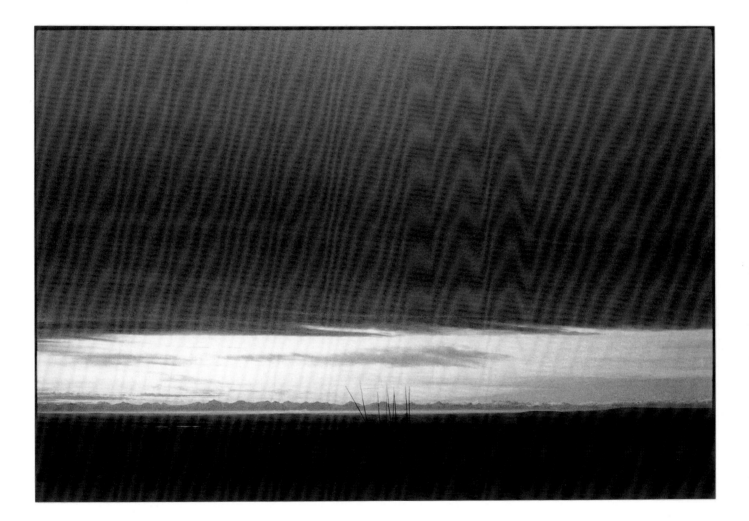

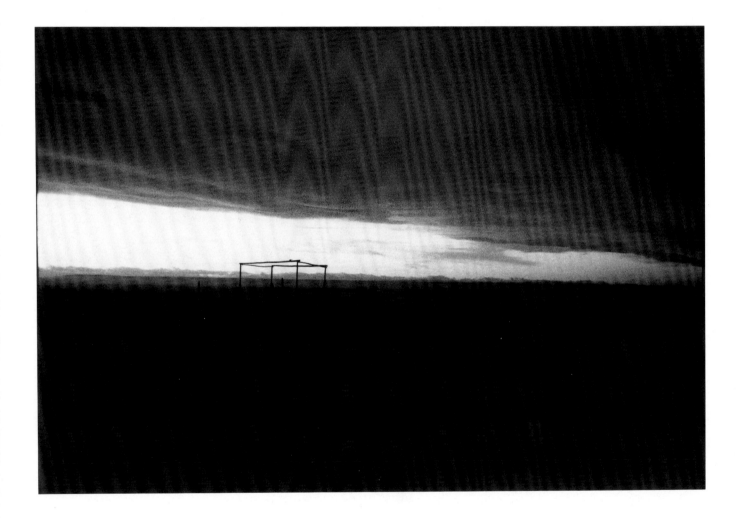

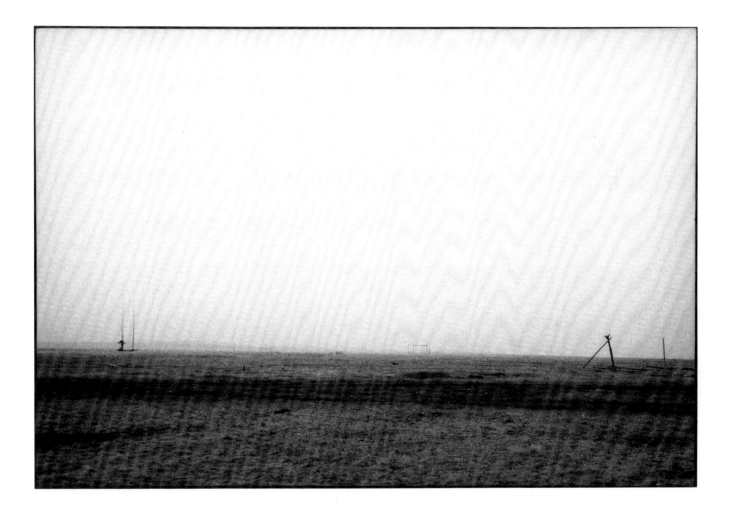

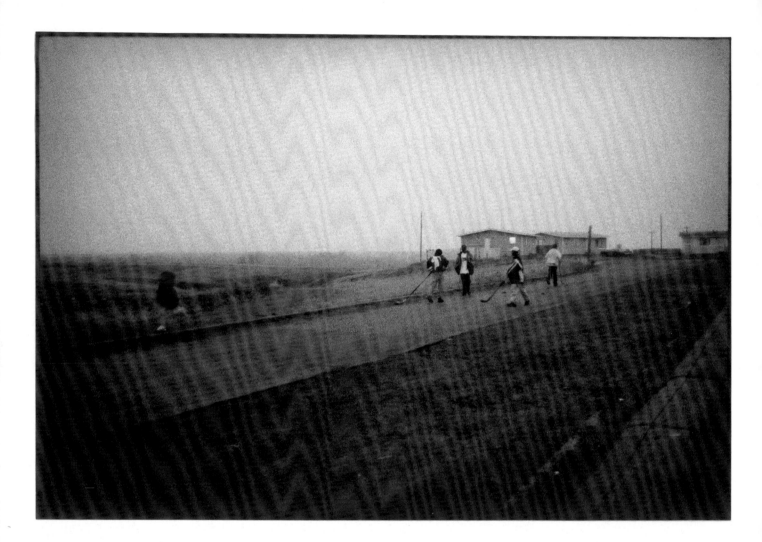

Good Friday 1997

Meet Elsie Bruised Head near the dump in Standoff. It's an incredibly windy, cold morning. She tells me that the big white stick she is carrying is to defend herself against attacks from badgers and wild dogs.

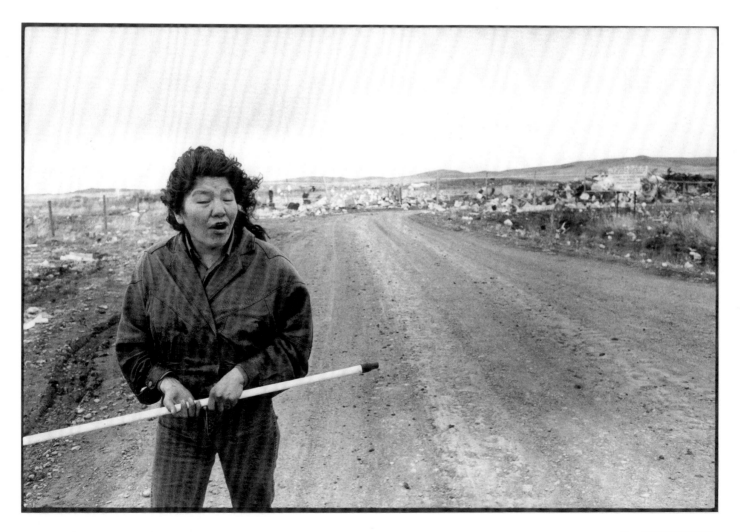

In the village of Levern I see a white dog licking the mouth of a dead black pup, vainly trying to summon it back to life.

Photograph the Good Friday pilgrims under a dark sky on the road to St. Mary's Church.

See perhaps a dozen dead dogs along the side of the road. They have an unfortunate instinct to chase passing cars.

Around 7:00 PM I'm driving out of Standoff, heading northeast toward Lethbridge. The sky is magical, unlike anything I've ever seen before, iridescent silver patches on slate grey. It descends magisterially over the northern horizon, filling the space with dark beauty. Then it hits me. Snow blasts straight back into my headlights. It's getting difficult to see where I am going. The snow builds on the road at a terrifying rate. I want to stop but I'm afraid I'll be hit from behind. I have no idea where the shoulder of the road is. I crawl along, nearly driving off the *left* side of the highway. I jam on the brakes but still seem to be moving and spinning in the suffocating white blindness of it. I slip into the ditch sideways, nearly tipping over. After several unsuccessful attempts, I make it out. All evidence of the road and other traffic has been obliterated by the snow. After what seems a terribly long time, it starts to ease up a bit. And then I see something, just barely discernible, on the horizon. *God* what a relief. It's the lights of Lethbridge.

Holy Saturday 1997

I stand on the edge of the St. Mary Reservoir with the sharp, powerful wind pressing me, pushing me back. It's exhilarating.

Late in the afternoon, I'm sitting in my truck outside the little general store off Highway 2 at the edge of Standoff. Sam Day Chief strolls over and introduces himself. There is a gentle yet theatrical quality to his expressive gestures as he speaks. He asks for a ride to nearby Fort Macleod. He tells me that he is a retired rancher who has helped with the band's Sun Dance for the past thirteen years. I drop him off in Fort Macleod, and he disappears into the handsome old sandstone Queen's Hotel on Main Street.

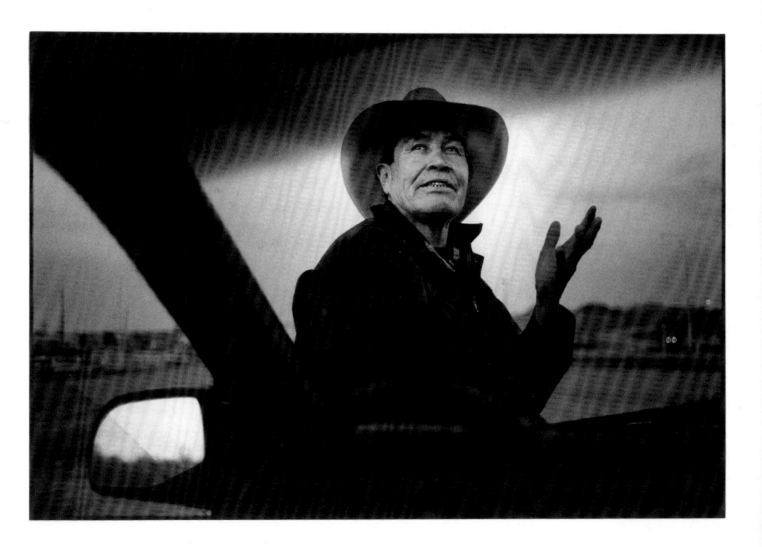

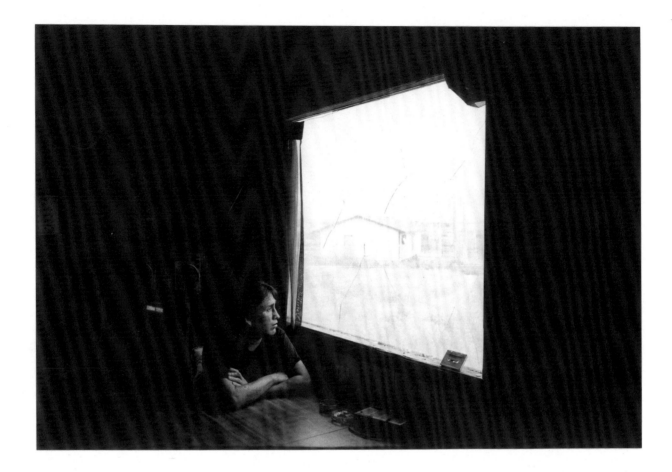

August 18, 1997

Photograph Merlin Chief Calf beside his big, cracked kitchen window, as his wife sleeps nearby.

On rain-drenched Highway 2, I meet Larry Hairy Bull and his pregnant wife, Bernice White Man Left. They are hitchhiking back to their home in Standoff. I offer them a lift. Larry tells me he used to play guitar for the country-rock group Stray Horse. After we arrive in Standoff, he looks back at me and lifts his hand to mimic a Native headdress.

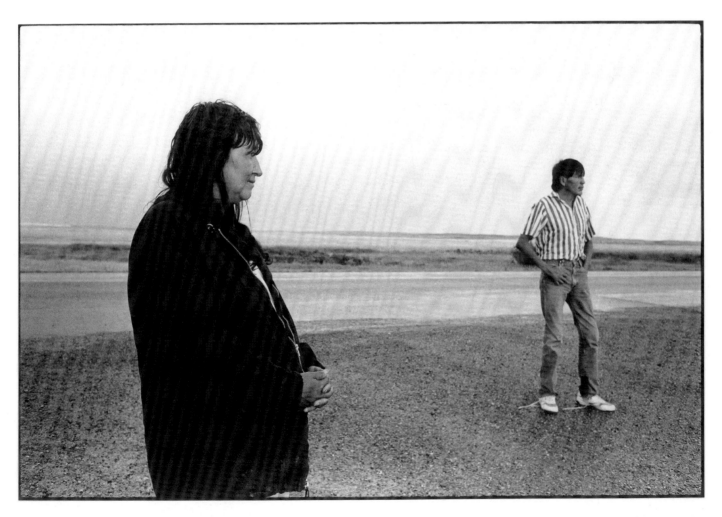

17—GEORGE WEBBER

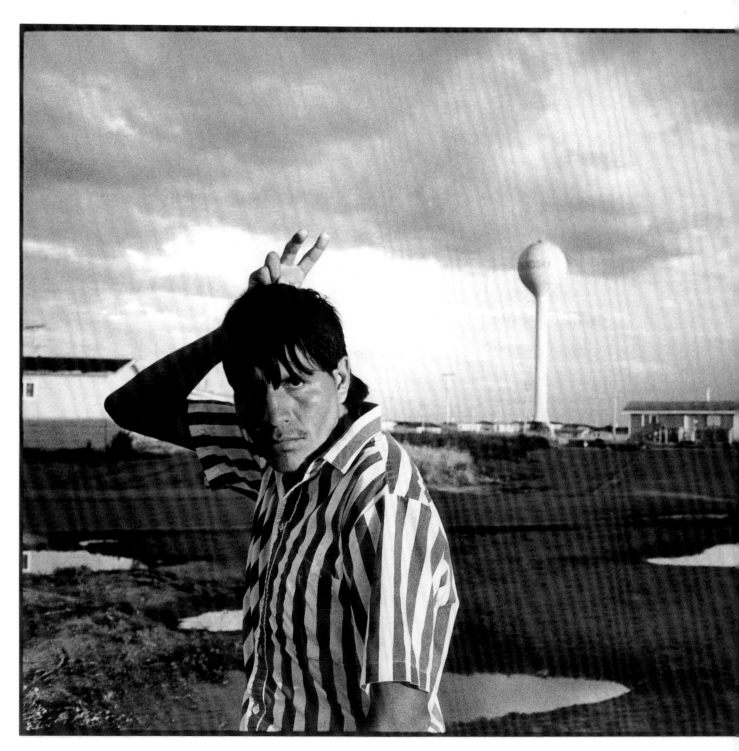

19—GEORGE WEBBER

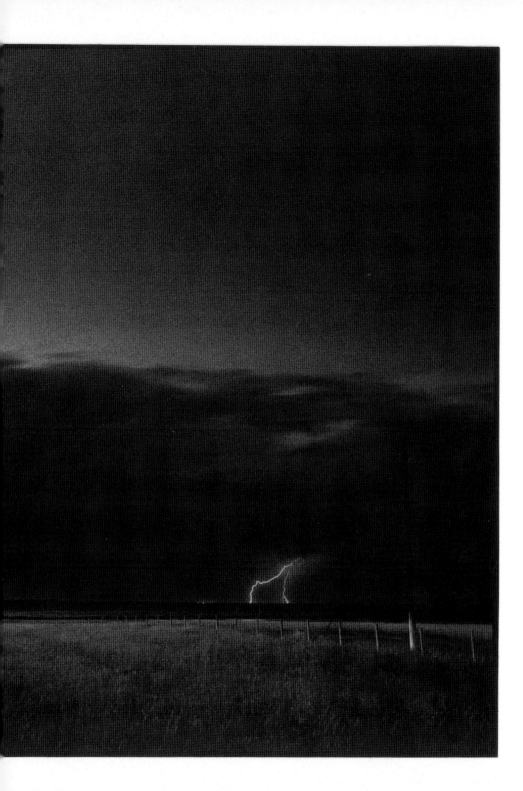

Driving toward Lethbridge, I pull over to photograph the rolling lightning storm.

August 19, 1997

Along a steep, sharp bank high above the Belly River, I meet Horace Shouting and his young son Stormy. As we walk, Horace quietly recounts turbulent and unhappy episodes from his life.

August 20, 1997

(8:00 PM) Completely calm, gentle warm evening, pastel blue of Chief Mountain and the Rockies … the glinting Belly River, high diffused cloud, a tiny, subtle patch of rainbow in the western sky, the sweet, warm ebbing light, the scent of clover.

October 17, 1997

Bring photographs back for the Panther Bone family of Standoff. Photograph young Tristan and Chantelle Panther Bone in the living room of their house.

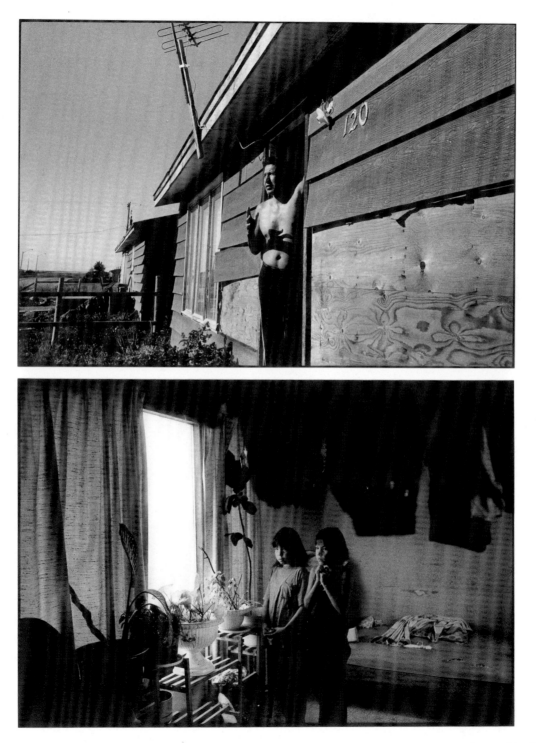

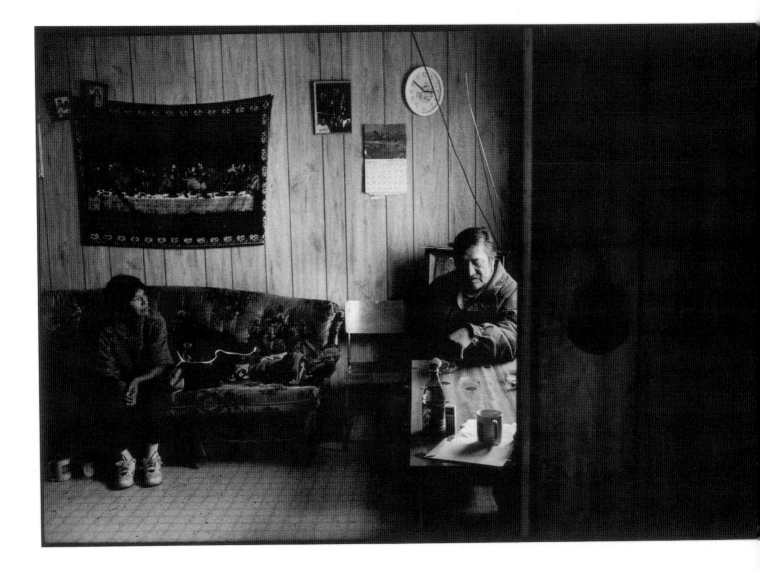

Photograph Roger Bull Shields in his kitchen. Behind him on the wall hangs a reproduction of *The Last Supper*.

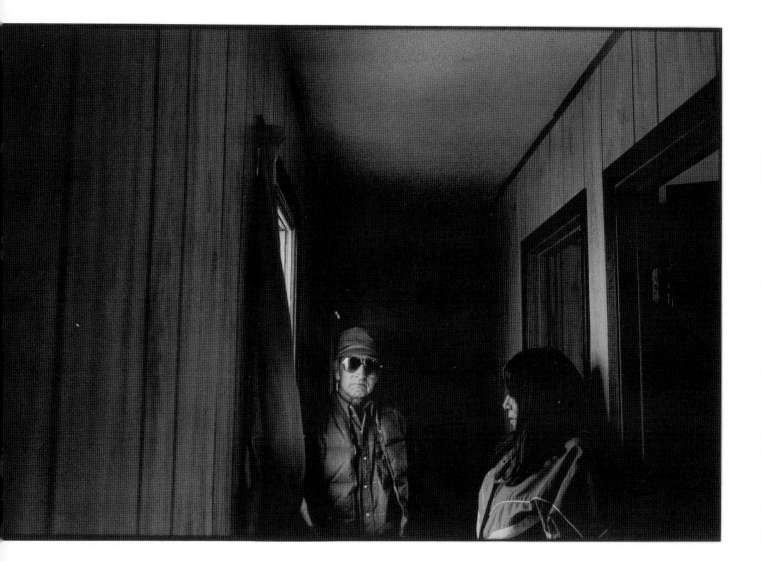

Meet and photograph Sandra Blackwater, an attractive dark-haired, middle-aged woman who is already a grandmother. She tells me that her first name in her native tongue translates as "Speaks Backwards."

Stop to visit Horace Shouting late in the afternoon. He and his wife, Lenora Scout, have been married for eight years. Last year, during a period of estrangement, he tells me that he "went down and down" during her absence.

Lenora started her first sweat lodge and fasting ceremony two days earlier. She will fast from Wednesday to Saturday. Horace tells me that he has fasted himself and that tomorrow, Saturday, is the worst day of the fast. It's the day when anger toward self and others can come most powerfully to the surface.

Horace invites me to assist at the sweat lodge tomorrow.

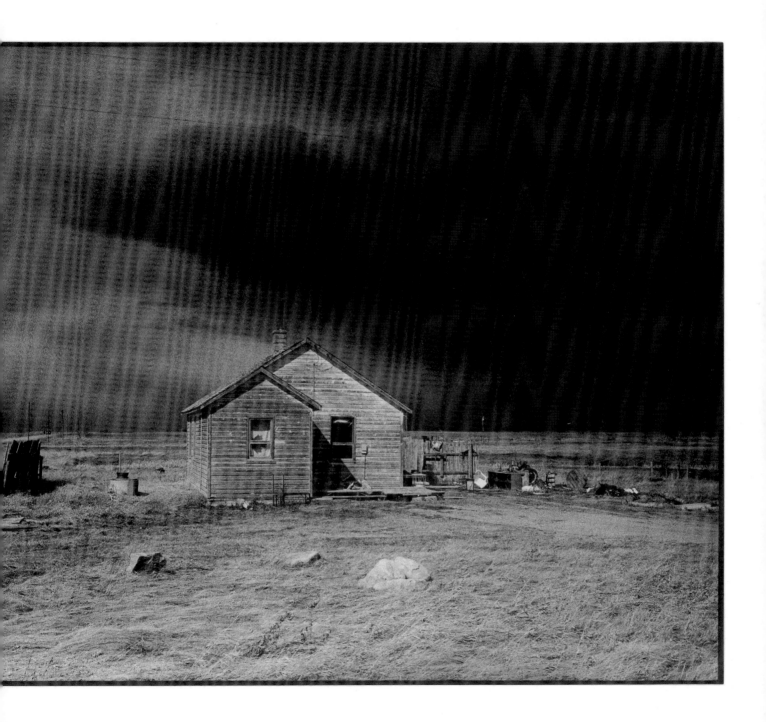

October 18, 1997

It's a grey, wet day. Horace tells me that it is a good sign, that the spirit is blessing the people by sending them rain, which they are permitted to drink. A group of six individuals, wrapped in blankets, enters the sweat lodge. I assist by carrying large, hot stones from the firepit with a battered pitchfork. I have brought tobacco as an offering, as Horace suggested yesterday. Lenora's younger brother, Chris, works alongside me. I ask him if he has participated in a sweat lodge ceremony. He tells me that he is not worthy to do so at this time, and his eyes fill with tears. The hot stones are placed in the centre pit of the sweat lodge, the front is sealed, and pots of water are poured over the stones. The interior fills with searing steam. Prayer and chanting begin under the direction of Keith Chief Moon. Toward the end of the ceremony, I can hear Keith begin a prayer for me.

Later, a small group of us visits the site that will be the home of a new Sun Dance site. The site is blessed by Lenora's father, Jordan Chief Moon. We are given food and asked to offer it, one at a time, to the Creator. We then link hands and individually speak our praise in honour of the Creator.

Jordan's wife prays and describes her husband as "a walking miracle" for the role he has taken in the spiritual ministry of his people after what had been a dark chapter in his life.

One of the participants, Annette, speaks of "trying to overcome my greatest enemy … myself." She tells me, "I dreamed this place … I could see Chief Mountain one way and the river the other way."

Lenora tells the group that those who fast gain a new sense of gratitude for the Creator's gifts, a heightened awareness and thankfulness for the gift of water. Then she turns to me and says, "The old Lenora will be left behind. The new Lenora is coming."

Later Horace says to me, "Your life will be better when you return from your journey."

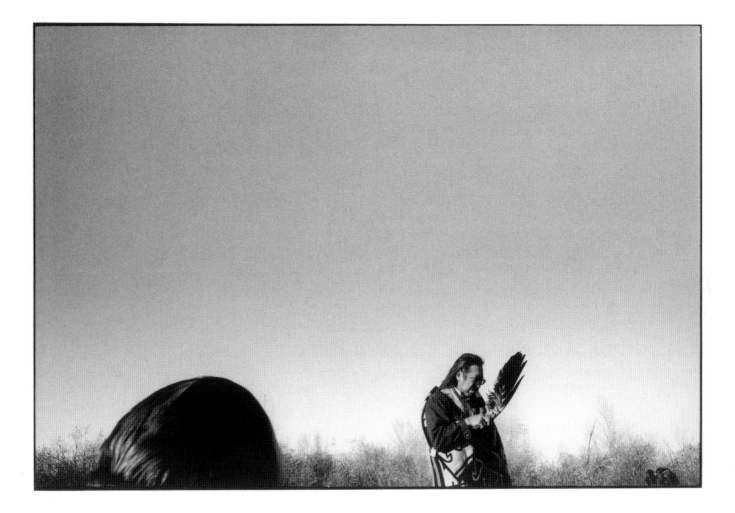

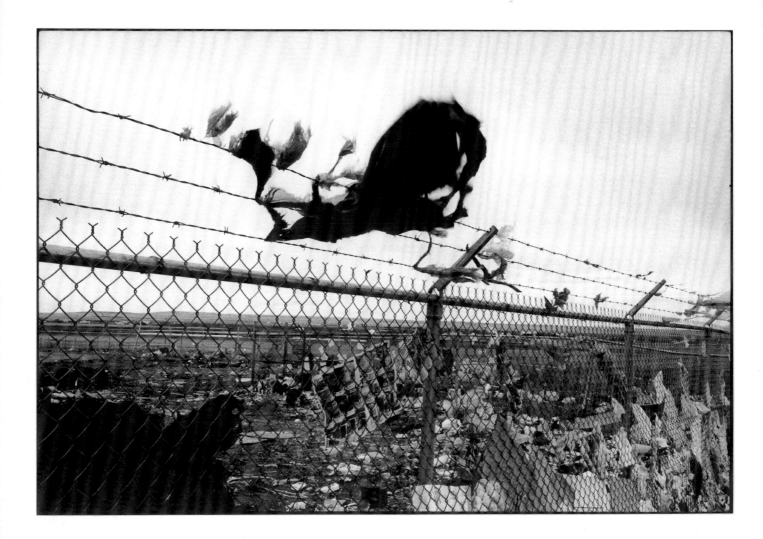

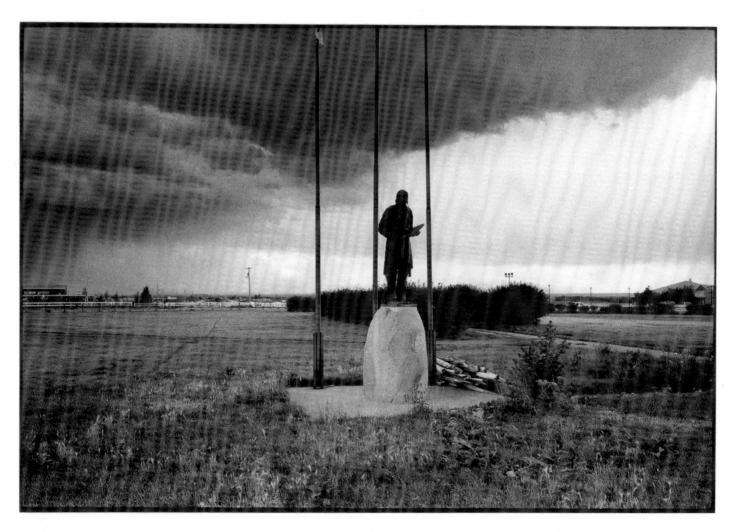

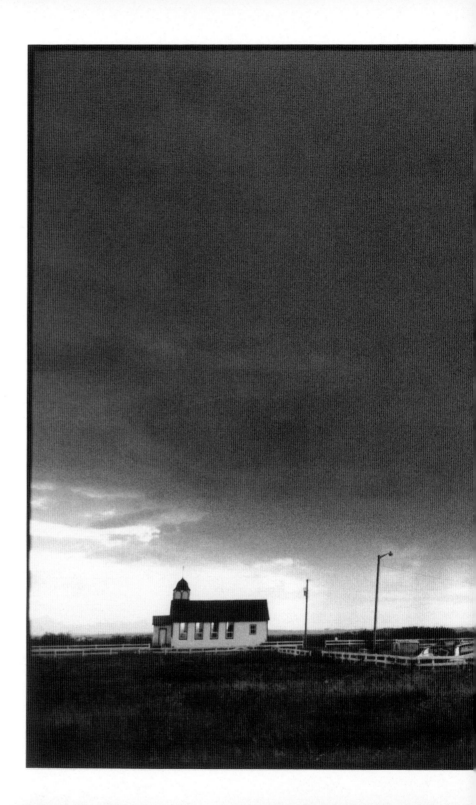

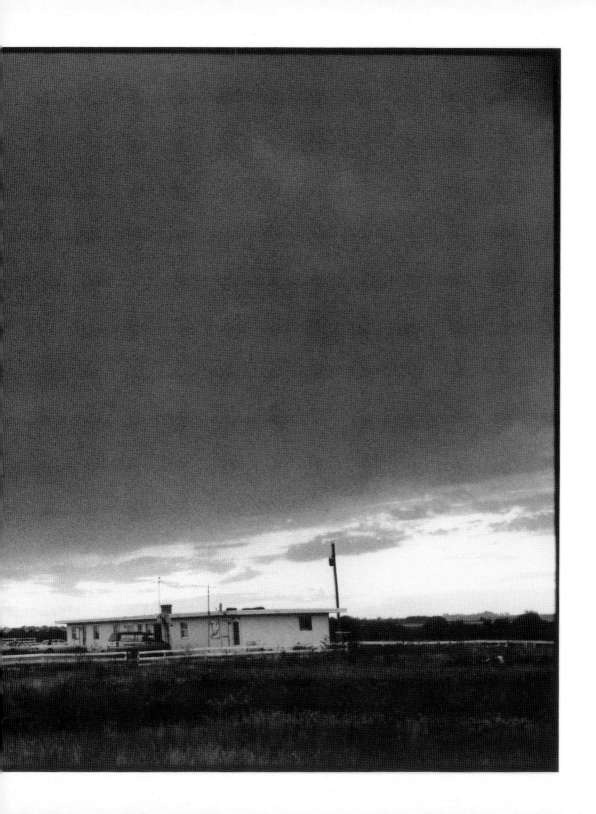

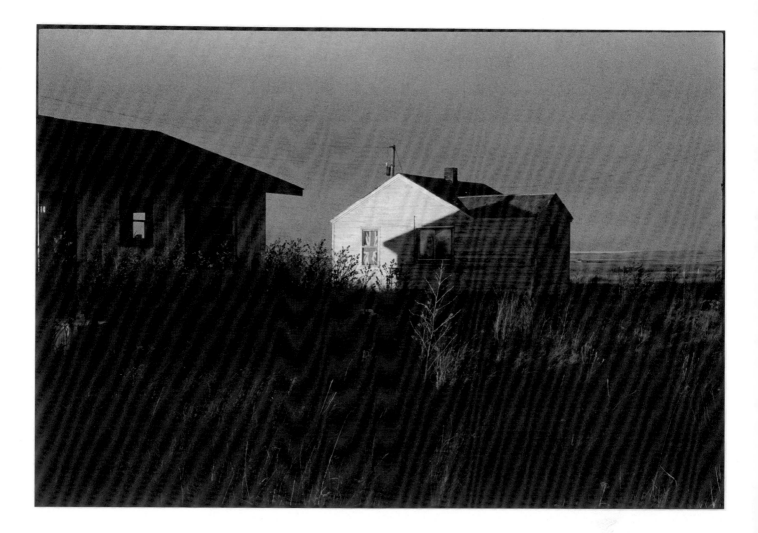

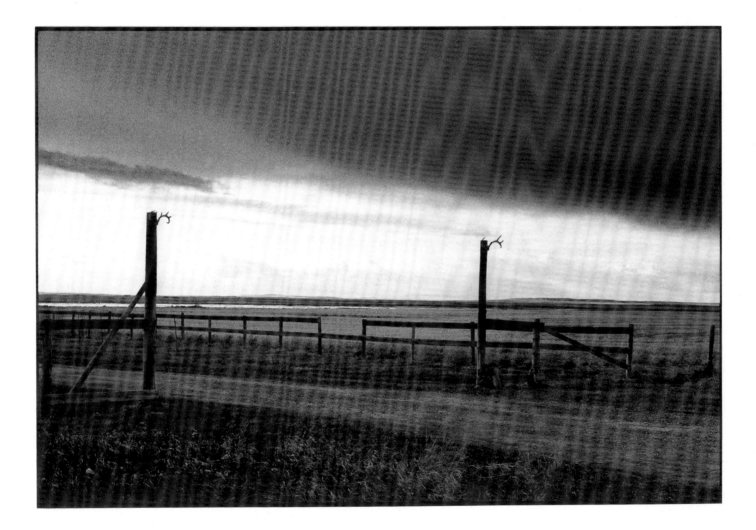

35—GEORGE WEBBER

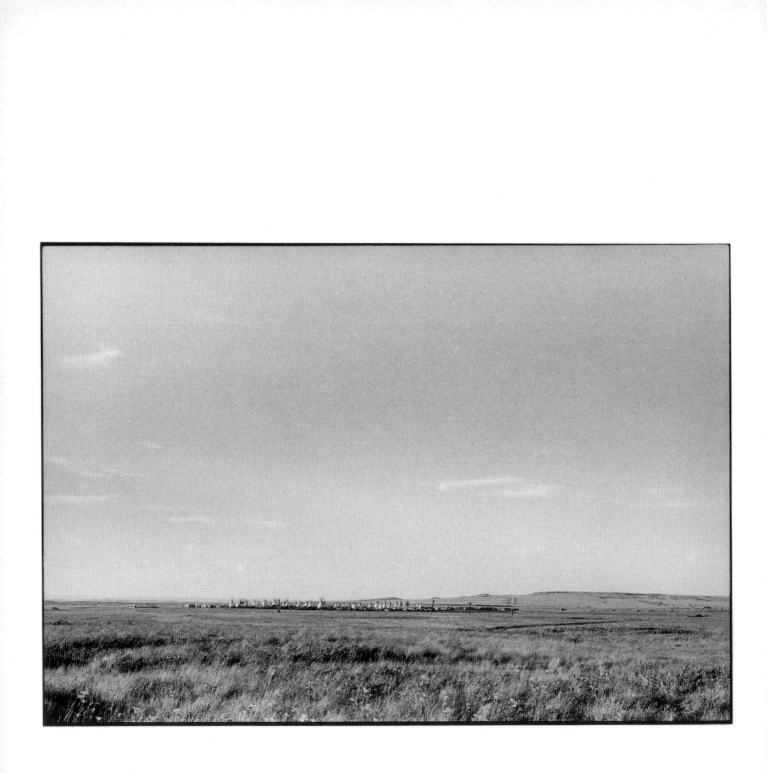

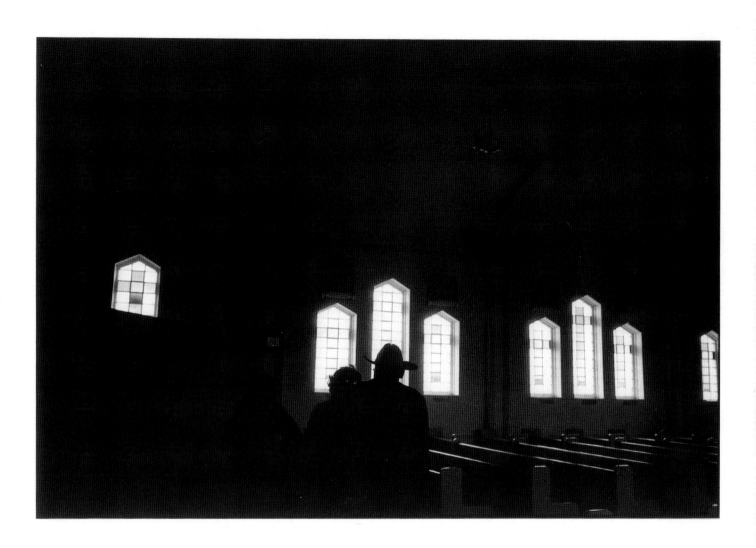

THE SEVEN DIRECTIONS

Holy Thursday 1998

Driving through Standoff I see a big, yellow dog running down the street carrying the leg of a calf in its mouth.

Good Friday 1998

Looking toward Chief Mountain from north of Standoff, I hear the slow, whispering hiss of wind rolling over the land, lifting the flattened prairie grasses. Later I come upon a large cluster of sweat lodges near Standoff. A tiny whirlwind skips through the site as I make photographs.

Meet Jane, a young woman from Britain now living in Taos, New Mexico. She recently met Keith Chief Moon when he travelled to Seattle to conduct a sweat lodge. She has come to Alberta to assist him. She tells me of the seven directions in Native spirituality: north, south, west, east (enlightenment), heaven, ground, and the great mystery. In the ebbing western light, Jane's deep brown eyes gleam and she tells me, "This is a place of possibilities. It's not as stratified and rigid as where I come from."

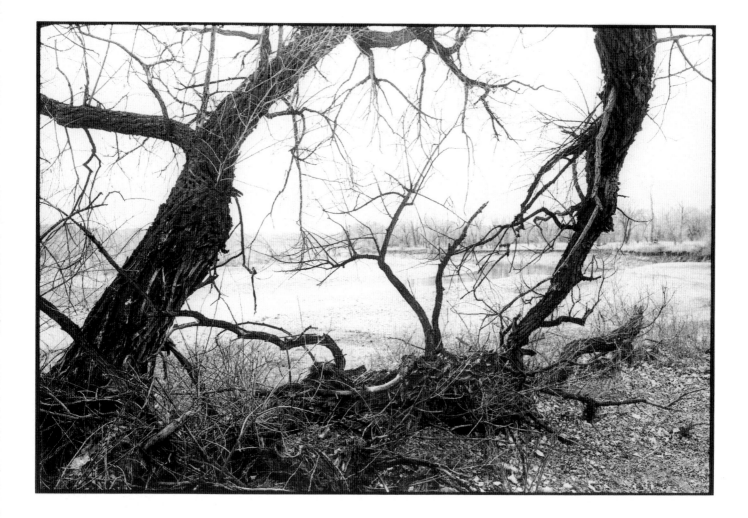

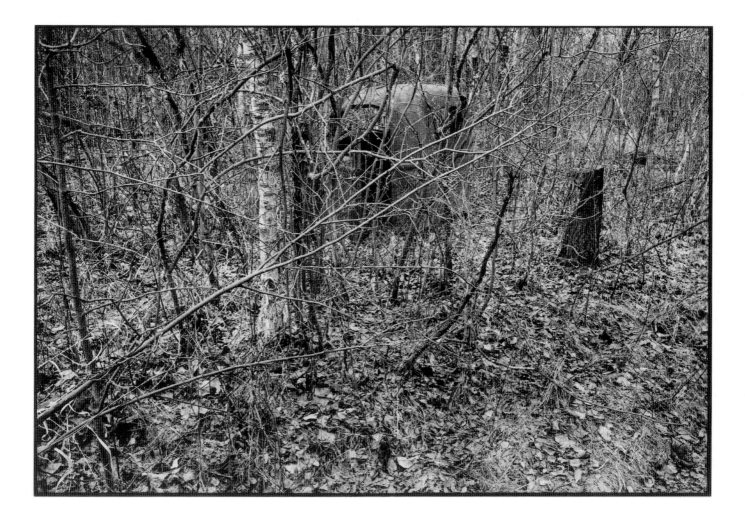

Holy Saturday 1998

Gather some small, flat stones on the south bank of the Old Man River.

Listening to the CBC on the truck radio, I hear the phrase: "You can't get into heaven. You must become heaven."

July 1999

A man sitting on his front step notices me walking through Standoff on a dusty, hot afternoon. "Are you a priest?" he asks. "No, just a photographer," I reply. Clergy and police are the only whites normally expected around here. He is Frank Smallface. We talk for a while and discover that we have a mutual friend, a Calgary basketball coach. Like many in the community, Frank, his wife, Randa Weaselhead, and their daughter, Kayleen, have been touched by tragedy. Four months earlier, Randa's eighteen-year-old daughter, Gina, was killed when the truck in which she was a passenger crashed near Standoff. The driver had been drinking. Recently, Randa tells me her daughter has begun to appear in her dreams, searching for clothing. Randa tells me that it is traditional for the dead to be buried in their own clothes. At the time of Gina's Catholic funeral, this was not done. Randa tells me that next year she will bury clothes for her daughter and dance for her in a memorial ceremony.

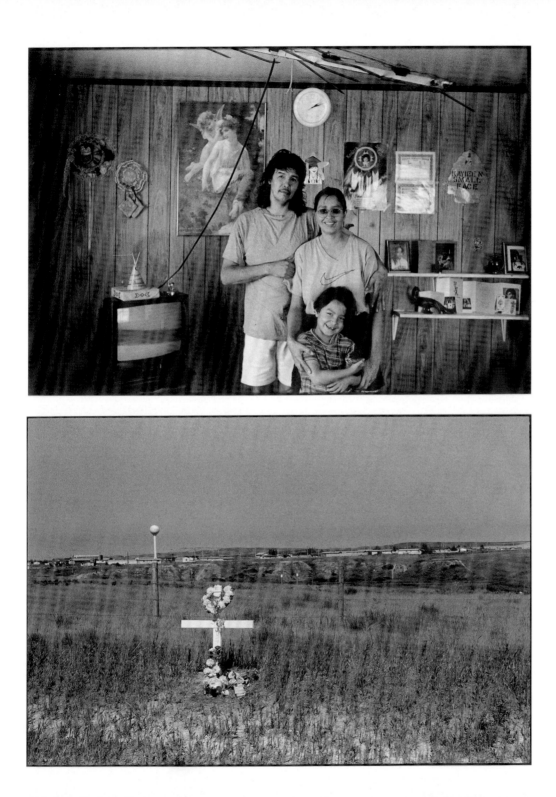

Crossed hockey sticks in St. Catherine's Cemetery near Standoff mark the grave of Bernard White Man Left, who died in 1995 at the age of forty-three. Red Crow, the great Blood chief and Treaty 7 signatory, is buried not far from this cemetery.

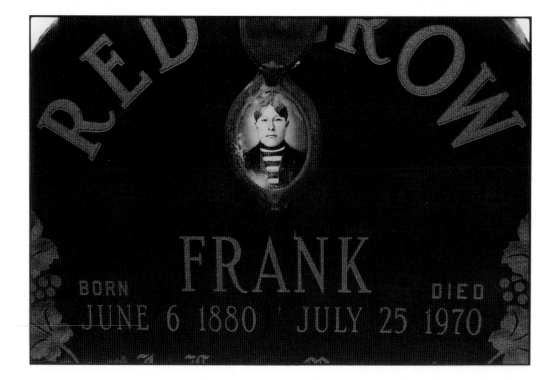

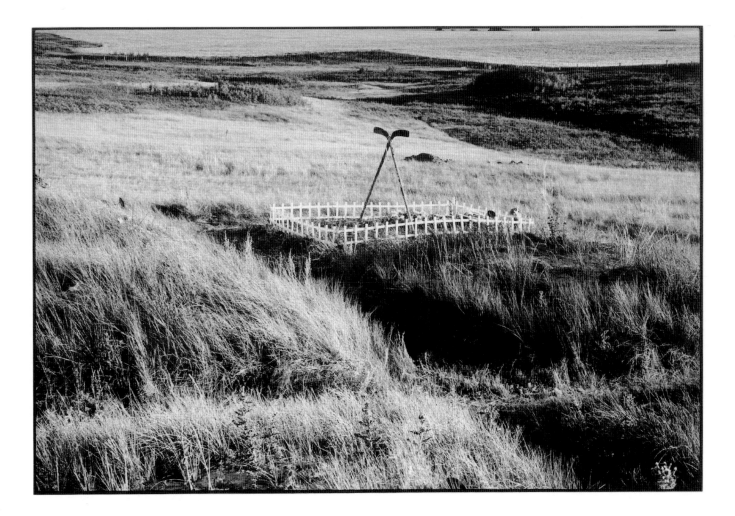

August 30, 1999

Meet with Horace and Lenora at their home. Horace tells me that he has recently started working on the upgrading of the St. Mary's dam.

He tells me that in 1995 Native people from the southwestern United States brought snakes to the Blood Reserve as part of their spiritual practice. A Blood Elder dreamed that it would mean five years of bad luck. This year, 1999, will be the final year of bad luck he tells me.

August 31, 1999

It's a windy, clear beautiful day, with the occasional cloud passing overhead. On the horizon, Chief Mountain is partially obscured by a narrow band of cloud. It seems so close but it isn't really. It's far off, on the other side of the border, in the U.S.

September 1, 1999

Elizabeth Eagle Speaker stands alone as I pull over at St. Catherine's Cemetery, near Standoff. She is awaiting the funeral service of her twenty-one-year-old grandson, Roland Scout, who was killed in a car accident. A friend joins her a while later, and the two wait in my truck until the hearse and funeral attendees arrive. During the burial Elizabeth cries out, "My grandson, my grandson!" then sobs quietly. Later we drive to St. Catherine's Church, where a simple meal has been laid out for the mourners.

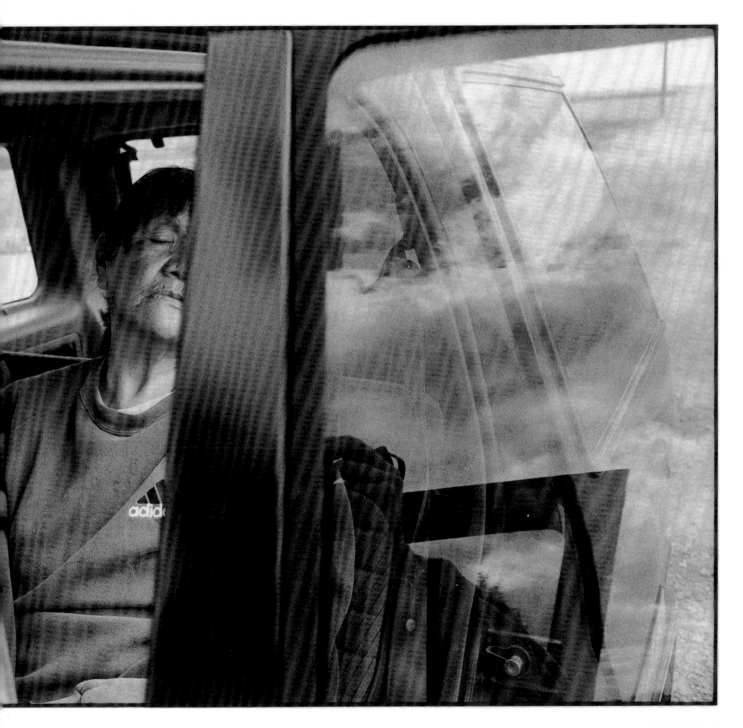

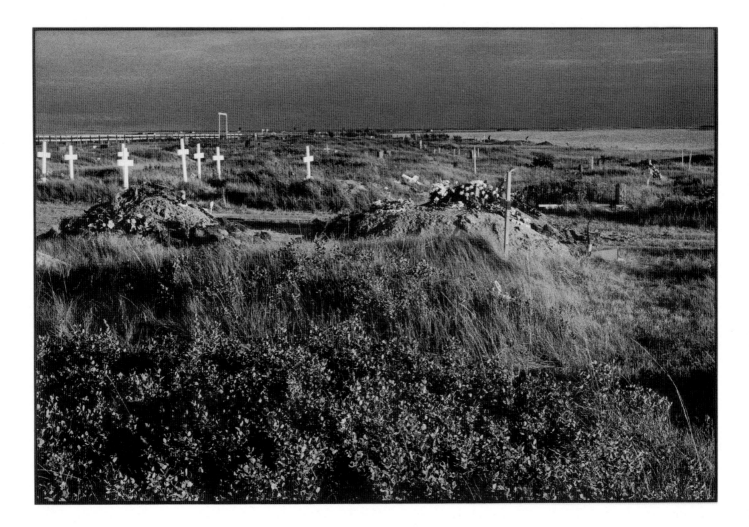

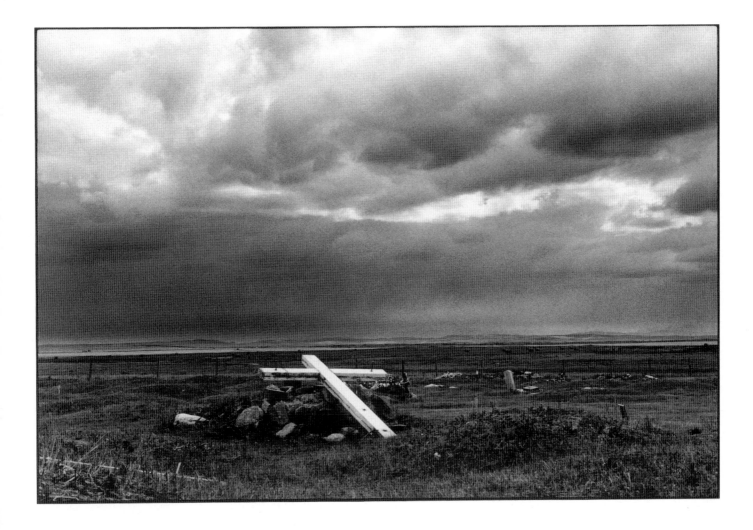

September 2, 1999

I meet rancher and rodeo competitor Corry Fox, who is
a descendant of Chief Red Crow.

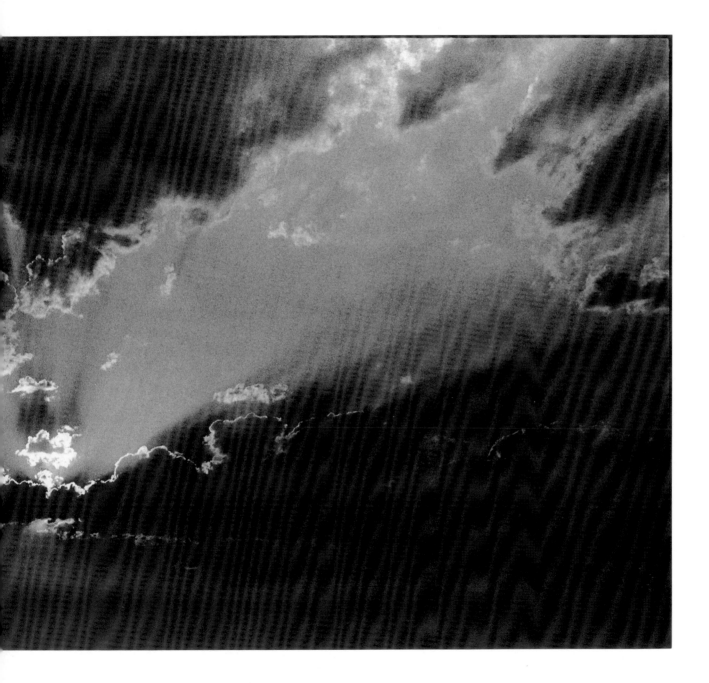

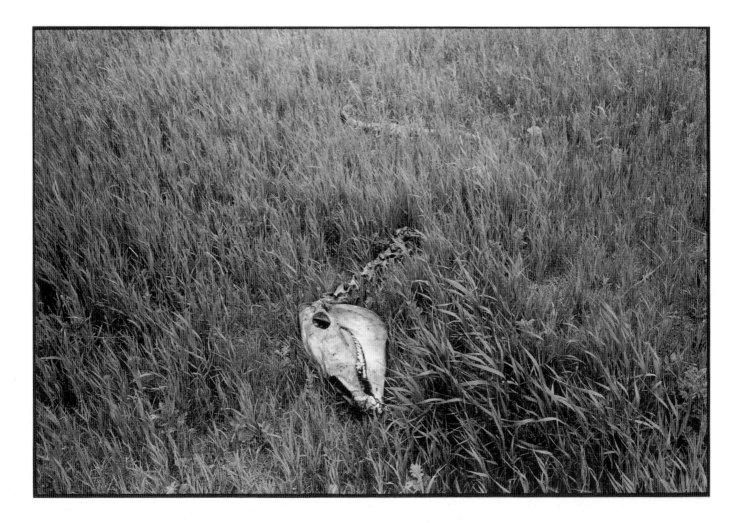

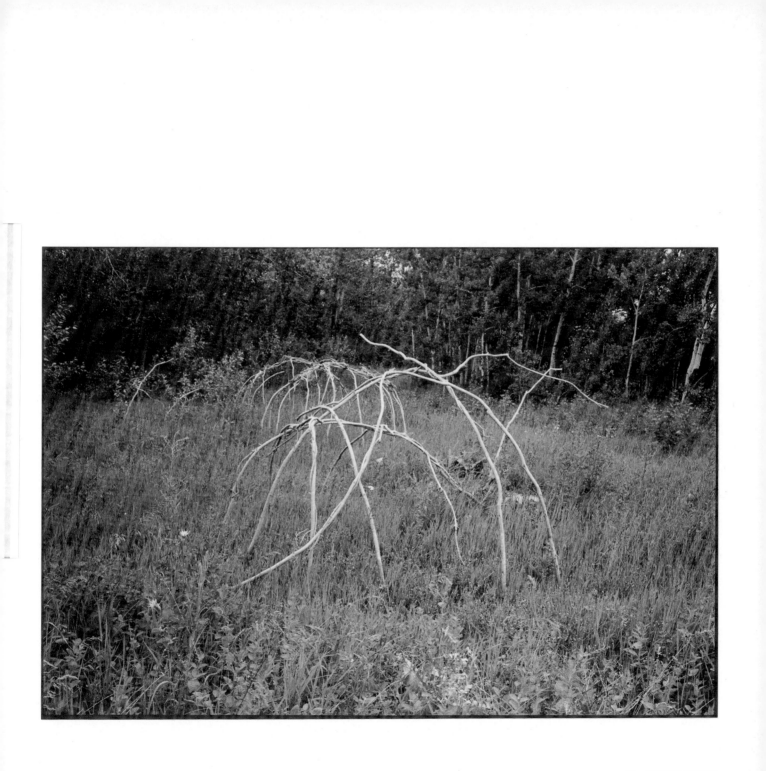

53—GEORGE WEBBER

GRATITUDE TO THE CREATOR

July 4, 2000

Parked on the edge of the road, I see a man walking toward me from a long way off. The man gets closer. It's Horace Shouting. He gives me a hug and shakes my hand. We drive into Cardston with his wife, Lenora, to buy lengths of yellow, red, white, and blue fabric for the Sun Dance. The colours symbolize the four seasons. Yellow is summer. Red is fall. White is winter. Blue is spring.

Later we go to the Sun Dance site. Keith Chief Moon, who has established this site, greets me with an embrace.

July 5, 2000

I enter the central arbour where the Sun Dance is to be held. This Sun Dance is known as the Keith Chief Moon Sun Dance, in reference to Keith, who has established the site. It will incorporate a piercing ritual that is not a part of the traditional Blackfoot Sun Dance ceremony.

I seek and receive Keith's permission to photograph the cutting of the centre tree for the arbour. Unfortunately, this is not conveyed to the others present. I meet with an angry response after taking several photographs. I'm given a stern warning by one man. I pack the camera away.

A tree is chosen, cut down, and carried back to the middle of the arbour. No part of the tree is allowed to touch the ground after it is cut. It is decorated with coloured cloth offerings. A hole has been dug in the earth, with the heart of a buffalo placed at the bottom. The tree is carefully positioned into the hole and the edges packed tight with dirt to hold it upright.

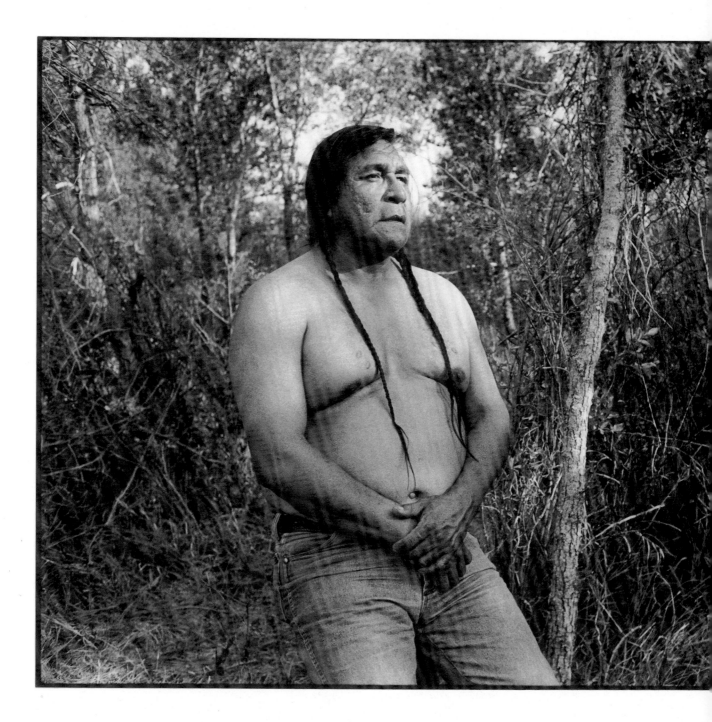

Early in the evening, Keith and I walk to the site from which the tree was cut. I make portraits of him with his shirt off. His chest bears scars from being pierced during previous Sun Dances. He tells me that he and his brothers played in this place when they were boys.

Horace then comes and, at my request, removes his shirt. His chest is smooth and unmarked. He is composed, but the enormity of the challenge he is about to embrace is evident in his heavy, downcast eyes. He speaks softly, telling me of his struggles with alcohol. Then he recounts a dream in which he saw an eagle perched on the east side of his house. The next night he had another dream in which he saw the eagle on the west side of his house. He took the dream as a sign that he must change the direction of his life.

Four hours after the photographs are made, Wednesday at midnight, he will enter into the mystery of the Sun Dance. "This is going to be a hell of an experience," he allows.

No photography is permitted once the Sun Dance begins.

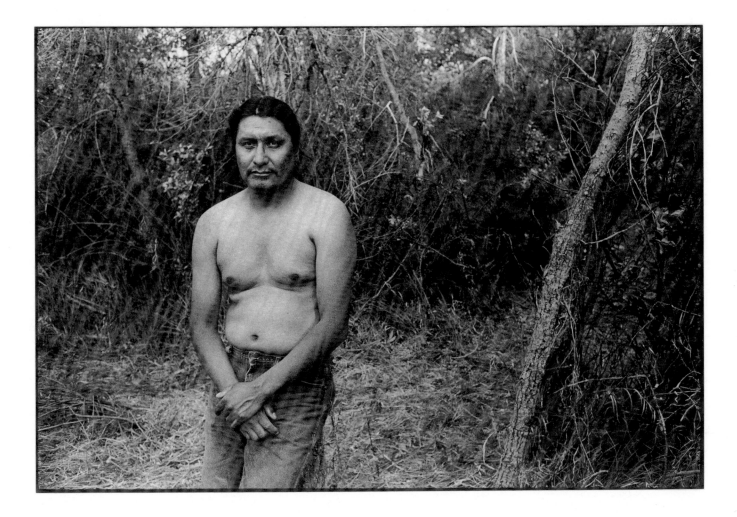

59—GEORGE WEBBER

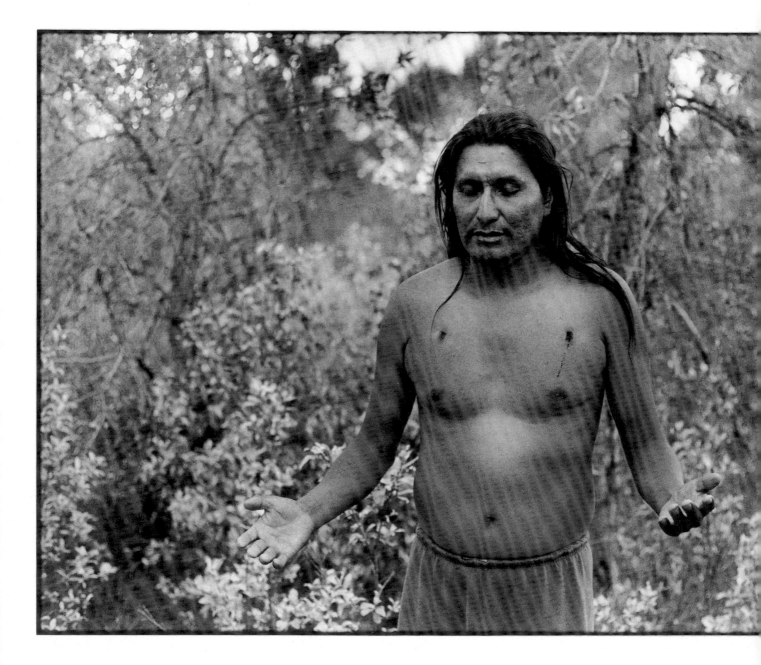

A scalpel is used to make two sets of incisions on the chest of the male Sun Dancers. For female Sun Dancers, incisions are made in the forearm. Through these incisions, a dowel of green chokecherry is inserted. Horace has elected the very rare and much more difficult four-corner pierce. Two sets of incisions are made on his back, near his shoulder blades. He is tethered with rawhide and rope to four posts that have been placed near the east entrance of the arbour.

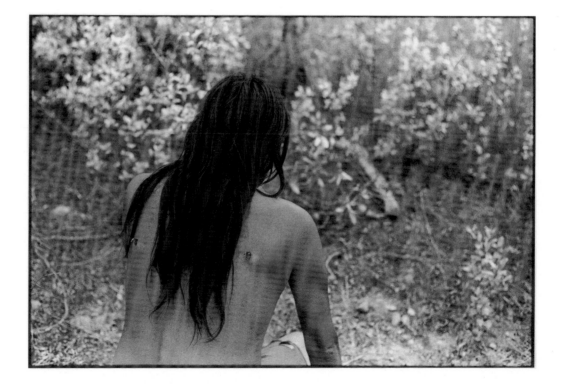

The other dancers, seven in total, are tethered to the centre pole. For the duration of the Sun Dance, the participants will chant and participate in the sweat lodge ceremony. They will have neither food nor drink.

Drums beat in unison under the scorching sun ... smoke drifts from the firepit. A group of perhaps 150 to 200 observers rings the inside of the arbour.

I am standing near one of the entrances to the arbour, amid a large group of observers. From near the centre post, Keith Chief Moon looks toward me, raises his arm, and points at me. Everyone turns to look. Then he gestures and indicates that I should remove my shirt.

I freeze.

A group of men standing nearby tell me to take my boots and cap and sunglasses off, as well.

In shock but realizing that I am being honoured with a request to perform a service, I quickly comply and remove my garments as everyone watches. I unhook my belt in order to cinch it up tight. Someone calls out, "Don't take off your pants." I want to explain but just nod as a roar of laughter goes up.

Moments later, Keith gestures me into the centre of the arbour and points at a staff supporting a wolf head and skin. I am to carry it around the arbour behind another man carrying a staff with an eagle's head and another carrying a buffalo skull. Both men are large and powerful, with deep tans. I am much paler than the silver-grey wolf skin I am holding. We circle the ring, leading a group of perhaps twenty people moving clockwise. At the north, south, east, and west entrances to the arbour, we turn to the right, making a 360-degree arc. We circle twice, stop, and then make four "charges" to the centre of the arbour to touch the tree with the buffalo skull, eagle head, and wolf head. We then exit the arbour on the east side, leading the group of Sun Dancers to the sweat lodge. I lay the wolf head and skin down carefully, retrieve my clothes, and get dressed.

July 8, 2000

Two deer run across my path as I approach the Sun Dance site.

I meet Bruce, a First Nations man from the Maritimes. He tells me of serving time in "The Crowbar Motel" (penitentiary) for manslaughter. He'd been in a fight with his wife's ex-husband and had accidentally killed him with a blow to the face. The beginning of his path as a peacemaker came during his time in prison. In the cell next to him was a Native American civil rights advocate. The man chanted for up to eighteen hours a day. Moved by his example, Bruce is working with Keith Chief Moon to bring the Sun Dance to the Maritimes.

July 9, 2000

It is Sunday, midday. The dancers have had nothing to eat or drink since Wednesday at midnight. That was nearly eighty-four hours ago.

Horace, with his four-point pierce, has been selected to break first. The slack on his ropes is taken up. He throws himself back, breaking the flesh at the pierce points on his chest. Then he throws himself forward. The skin near his right shoulder blade breaks. He throws himself again and the skin near his left shoulder blade finally breaks. He is near completing his great ordeal. With chanting, drums, and rhythmic dance, he and the seven remaining male dancers circle the arbour. They stop and throw themselves back into the waiting arms of their supporters. Finally the women, who have been pierced through their arms, stand while their supporter grasps the chokecherry dowel and pulls it down with a sharp jerk, splitting the skin.

With the grace of the Creator, Horace has endured what surely would have been unendurable otherwise. He drinks orange juice with a deep, unquenchable thirst before he and Lenora leave for home.

Something of the meaning and purpose of the Sun Dance tradition is later explained to me. First, it brings those who participate an enormous sense of gratitude to the Creator. It clarifies the nature and source of all gifts, including the gifts of life, food, water, and all that sustains life.

On another level, a practical level, it teaches grace under pressure.

It teaches survival.

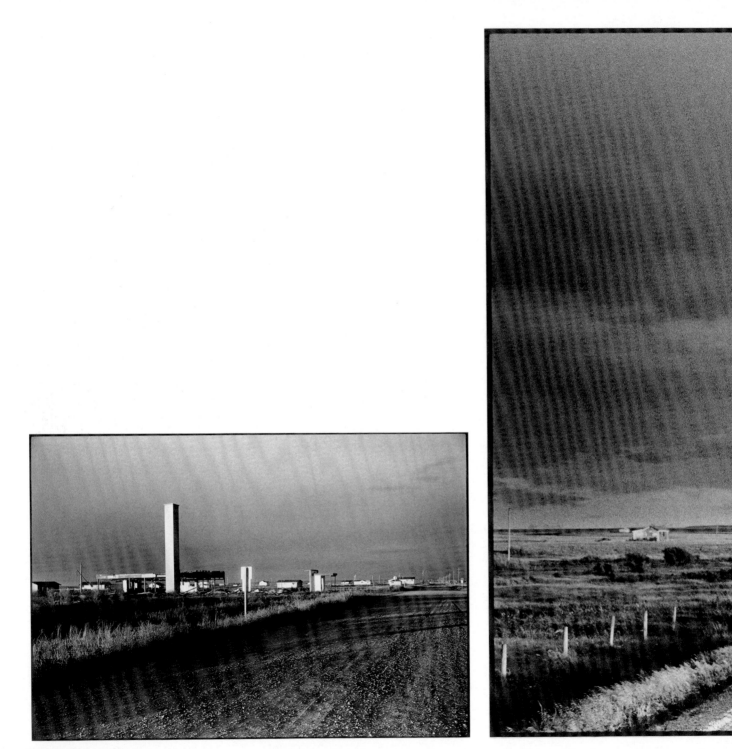

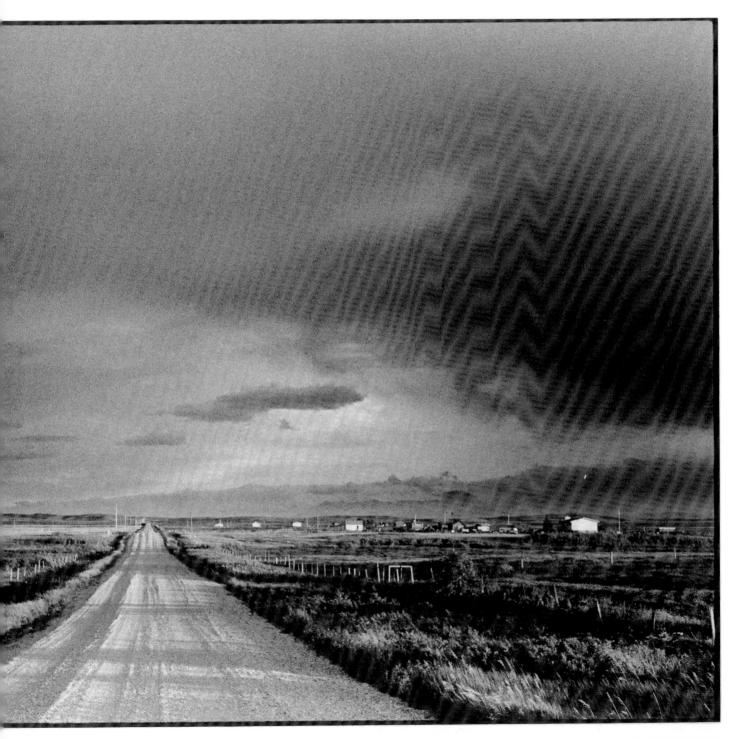

67—GEORGE WEBBER

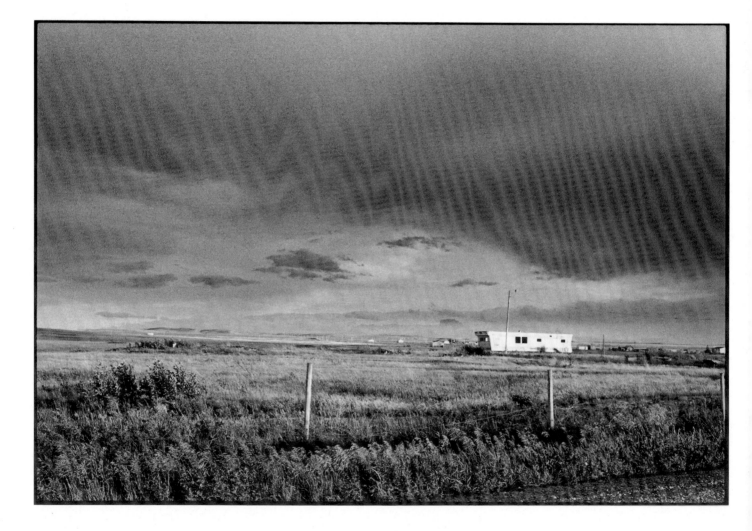

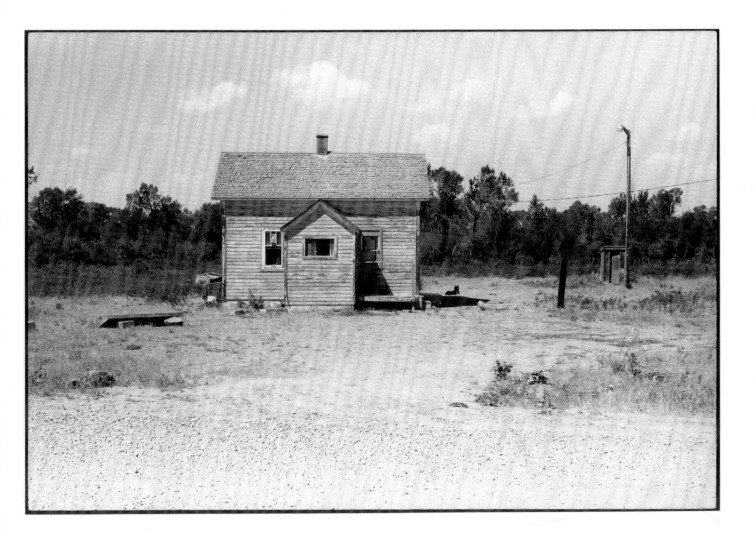

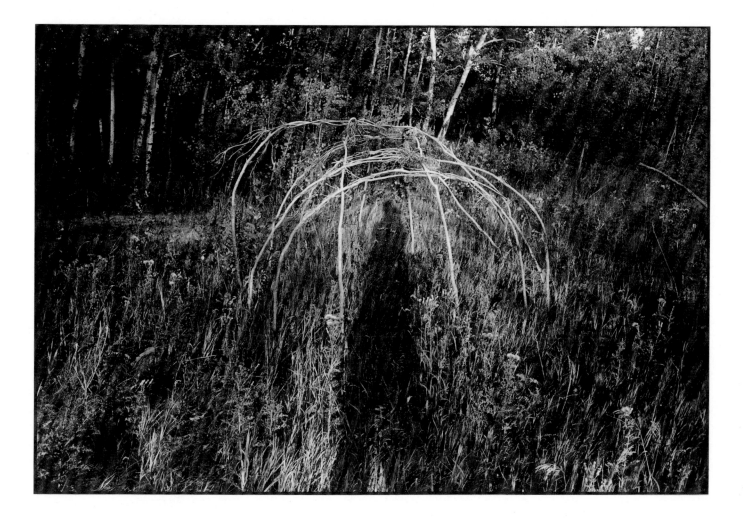

STORM CLOUDS

Good Friday 2001

I return to Standoff to see Frank and Randa. I haven't seen them in nearly two years and wonder if they'll remember me. Walking up to the front of a house, I wonder if this is the right place. I remember the exterior being faded and peeling, but this one is gleaming white in the late-afternoon sun. Randa opens the door: "George! I had a dream that you'd be coming."

July 21, 2001

Watch young "Lacey," who looks to be about nine years old, competing in girls' barrel racing at Kainai Days in Standoff. She's wearing a shiny white shirt, a white cowboy hat, and brand-new, black Wrangler jeans. Her thick, gleaming dark hair runs down to her waist. She rides fearlessly, her lithe little body bouncing and bobbing on the back of her horse. She is so tiny and so brave.

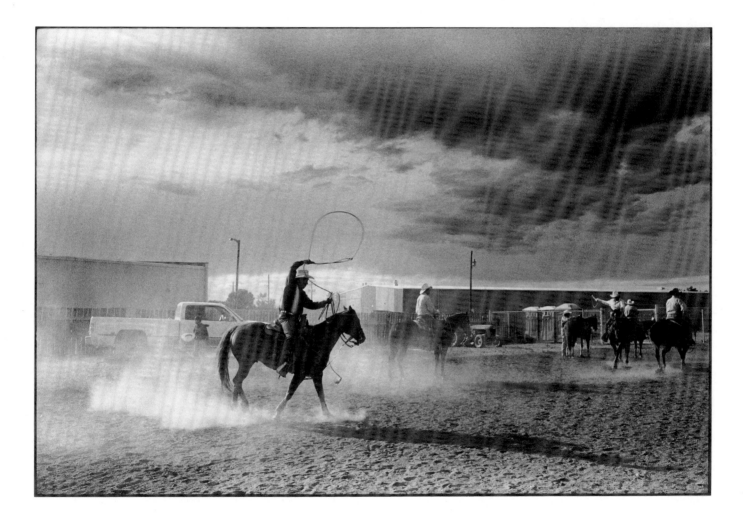

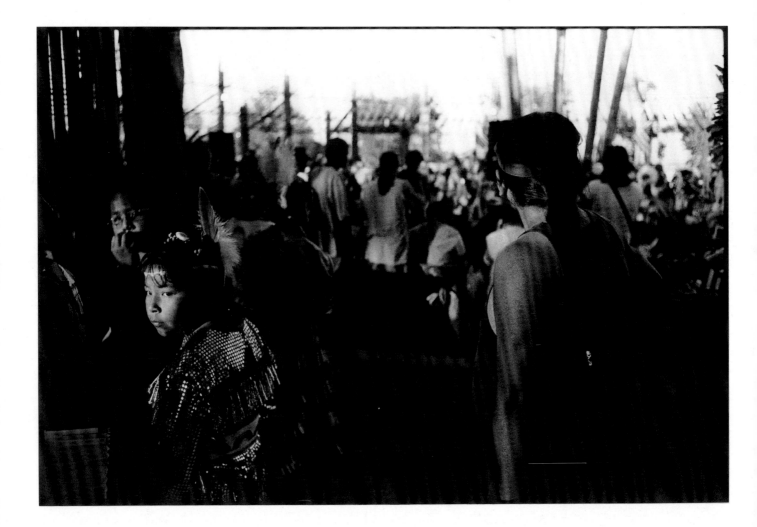

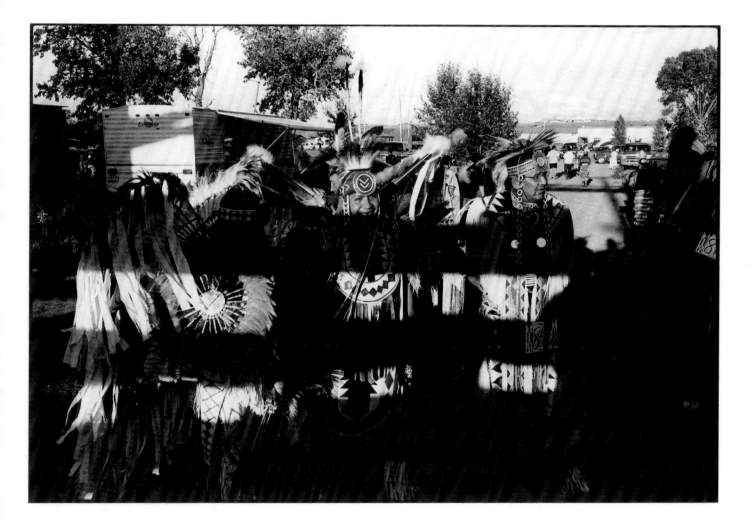

Meet sixteen-year-old Sharlee Weaselhead. She is full Blood Indian, nearly six-feet tall, and exceptionally beautiful. She is introduced as she gallops into the rodeo ring to compete in women's barrel racing. We learn that she has been signed by the Ford Modelling Agency and will be leaving the reserve for New York shortly.

Behind the rodeo chutes, I meet and chat briefly with Tyler Little Bear. I take a few photographs of him. He doesn't weigh much, maybe 150 pounds. But he's tough and he's sinewy. He rides bulls. A bit later, I watch as he is bested by his ride, the aptly named "Search and Destroy."

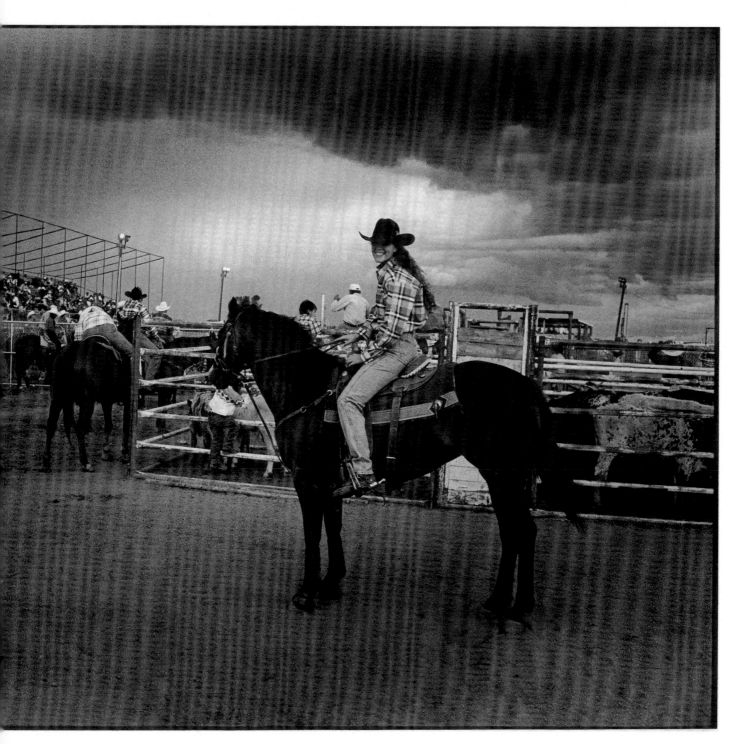

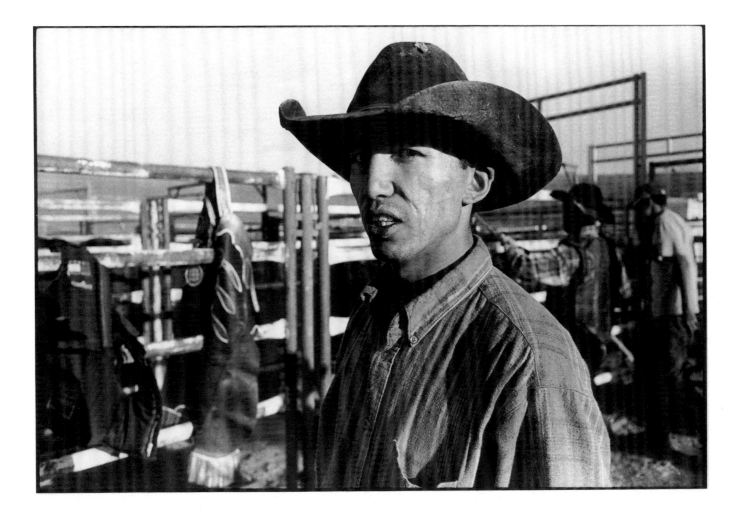

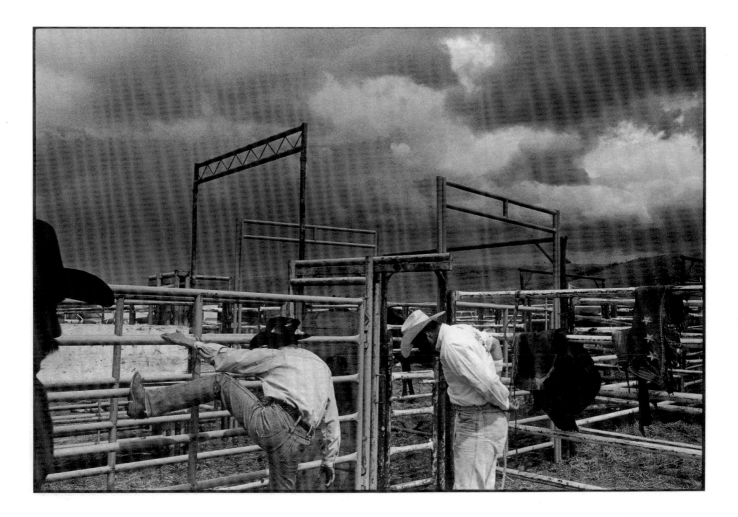

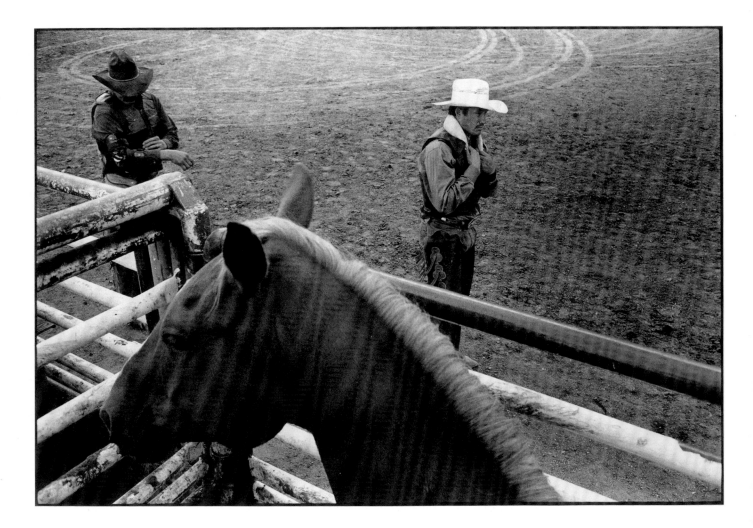

July 22, 2001

Under the gathering dark afternoon clouds, Tyler rides again. He's bucked early. The bull's hoof crashes into the back of his head, ramming his face into the dirt. In an instant, a scarlet pool forms around his down-turned head. Other cowboys run into the ring and gently turn him over on his back. He is motionless. A dreadful silence comes over the crowd. A little boy standing nearby turns to his friend and asks, "Is Tyler in heaven now?"

He's lifted gently into an ambulance and transported into Standoff. I drive over to the clinic to check on him, but he's been transferred to Lethbridge.

As I'm driving toward Lethbridge, a dark, heavy rainstorm crashes down. It's followed by a shaft of brilliant sunlight and a double rainbow that parallels the highway.

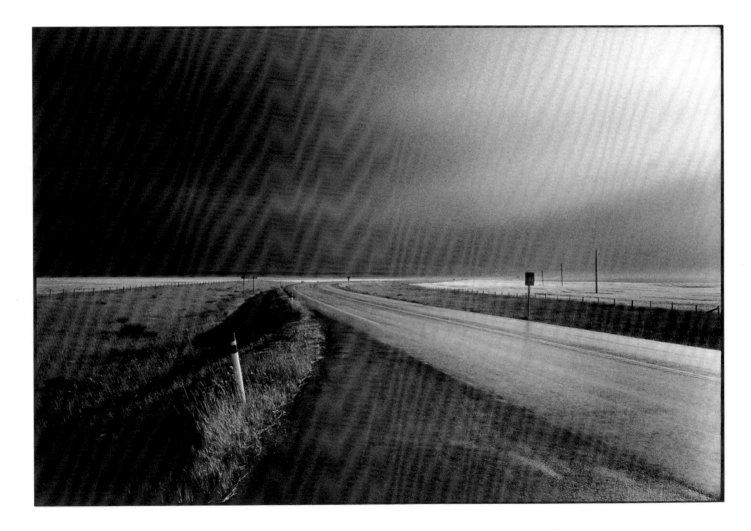

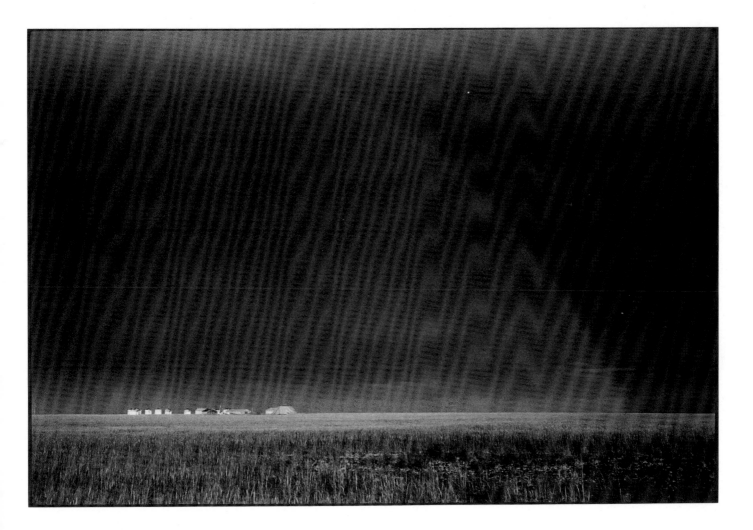

July 26, 2001

Tyler has been transferred to Intensive Care at the Foothills Hospital in Calgary. I stop in to see him with the pictures I'd made the day before his accident. He doesn't remember me. Bandages form an "x" over his right eye. He has a rosary around his neck. He tells me that his right eye has been damaged and knocked out of alignment and that he will be going for corrective surgery in a few days. We talk for a short while. I tell him of our brief meeting last Friday. As I'm leaving, I see him tipping and twisting his head back in order to better see the photographs he's holding in his hands.

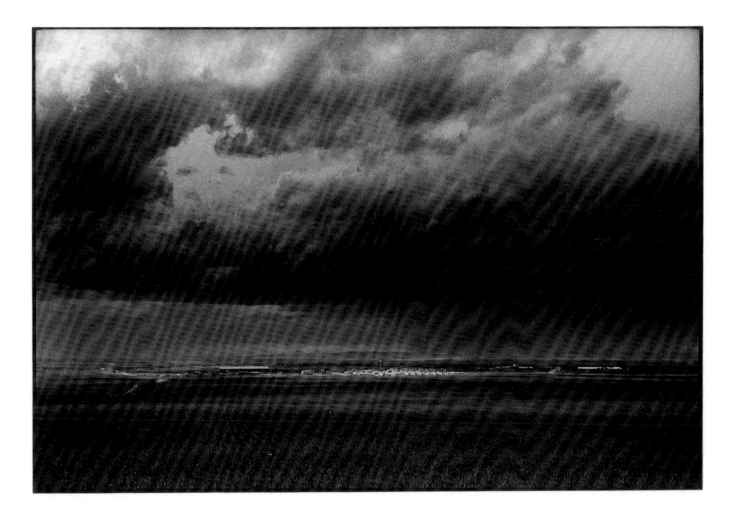

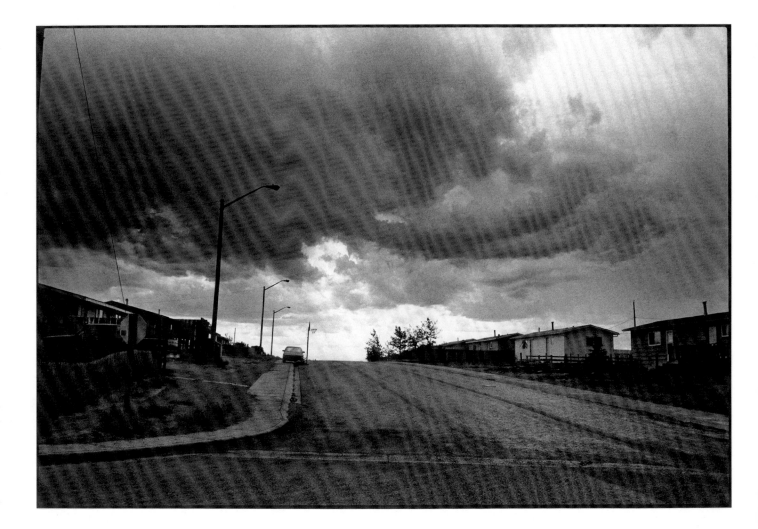

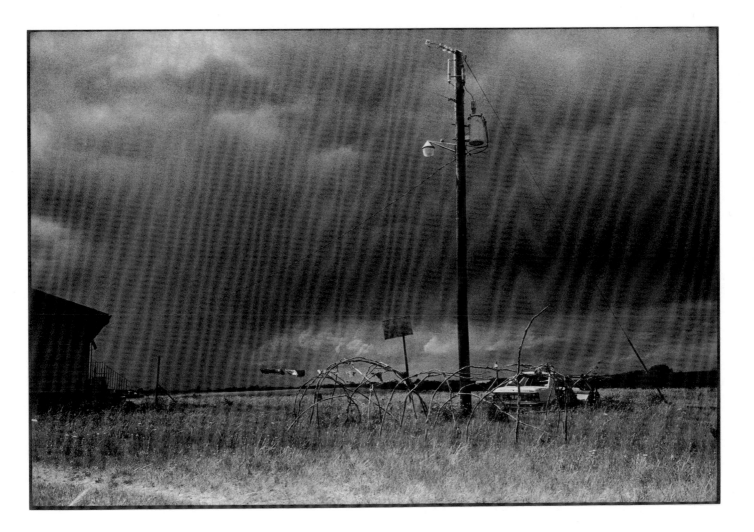

Good Friday 2003

Photographing in the dense brush along the Belly River.

93—GEORGE WEBBER

THE AWARENESS OF THIRST

August 28, 2005

The morning sun creates a brilliant running highlight in the Old Man River as I cross the bridge onto the reserve. A deer leaps a fence and darts across the highway in front of me.

I drive to Standoff, planning to visit Frank, Randa, and Kayleen. I approach the door of the house I think is theirs and knock. An elderly woman opens the door and I explain that I'm looking for Frank and Randa. She doesn't appear to understand. She replies in a language I do not understand. We attempt to communicate for several minutes with no success. I thank her and head back to my truck. Glancing back, I notice four young men dressed in black a little ways away, walking toward me.

I look back toward the truck. The street is empty, except for me and them. I can feel a ripple of fear.

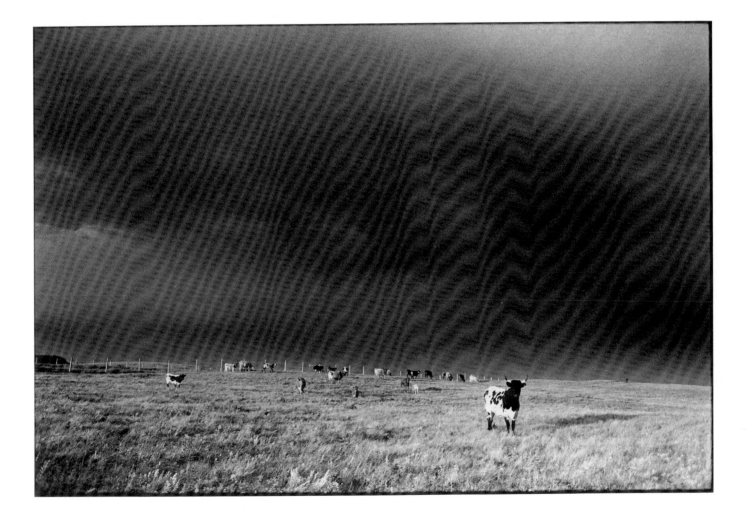

I get to the truck, get in, close the door, and lock it with my elbow.

The young men walk past, cross to the other side of the street, and stop on the sidewalk. One of them looks back at me and jokingly says to me, "Hey, white guy, lend us ten dollars, okay?"

I smile back, breathing a sigh of relief, and glance to my right where my camera bag is sitting. I reach in to pull out a camera. I glance back to my left. The men have circled back, surrounding the truck. One glares through the window and yells, "This is the west side, fuck off bitch!" and starts violently yanking on the door handle.

They all start pounding on the side of the truck and the windows with their fists. I try to quietly explain that I have come to see Frank and Randa. The pounding escalates. I start the truck and start to drive very slowly, with the pounding continuing. I speed up a bit and they fall away at last. This sudden, unprovoked violence and hatred leaves me feeling shaken. I realize that if they had gotten into the truck, there would have been no one around to help me.

I drive out of town and get to the highway, not exactly sure which way to turn. I decide to head south toward the Keith Chief Moon Sun Dance site. On arriving, I notice that some new structures have been added since I was last here. The remoteness of the place that had once seemed so soothing now puts me on edge. I keep looking over my shoulder at every sound, keenly aware of my isolation and vulnerability.

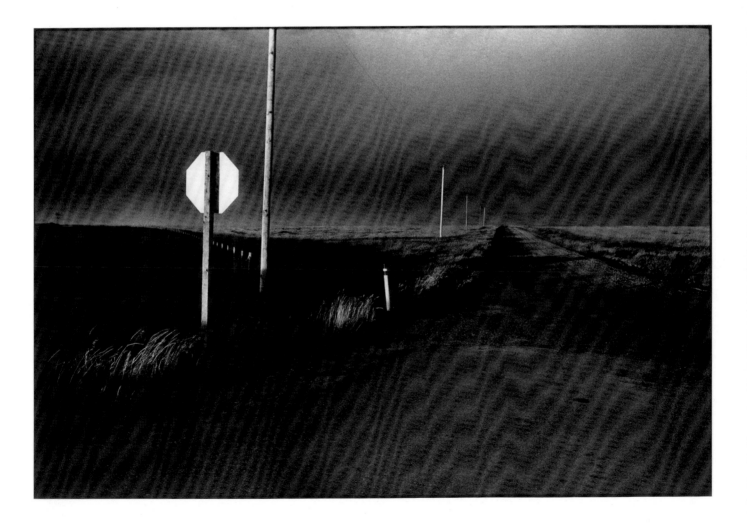

I quickly return to my truck and drive away from the site, soon arriving at a fork in the road. Going up the incline to the left, I recognize Horace and Lenora's robin's-egg-blue house. I hear loud chanting playing on the stereo. I knock and hear someone approaching the other side of the door behind the peep hole. The door remains shut. I return to the truck, noticing a tangle of broken furniture and toys in the front yard.

A little while later, driving down a rough gravel road near the community of Levern, I slow down for an approaching car. I glance at the driver. She looks at me. It's Lenora. We slow down, stop, and back up until we sit across from each other, as the dust rises and then settles. Horace gets out of the passenger side and we shake hands. He looks very thin. He tells me that he is suffering from an ulcer and has not been able to fast or complete another Sun Dance since 2001.

I tell him what happened earlier in the day in Standoff. He shakes his head and tells me about the worsening problems with crystal meth and cocaine on the reserve. Some young men are modelling themselves on gangsters, using intimidation and threats against others. There's bad blood and ongoing fighting between the different communities of the reserve.

He points to a "T" intersection not far from where we are standing and tells me that a thirteen-year-old girl was recently killed there in a car accident.

Spending time with Horace has calmed me down a lot. We agree to meet tomorrow afternoon. I return to the Sun Dance site. After a short time, Sean Chief Moon, son of Keith, appears. He tells me that he completed his first Sun Dance in July. The rest periods were the hardest part, he says, because that's the time when the awareness of thirst and hardship are felt most acutely. I show him some pictures from previous trips to the reserve. He recognizes the picture of Larry Hairy Bull, the man in the striped shirt I had picked up, along with his pregnant wife, and driven to Standoff. He tells me that Larry has died.

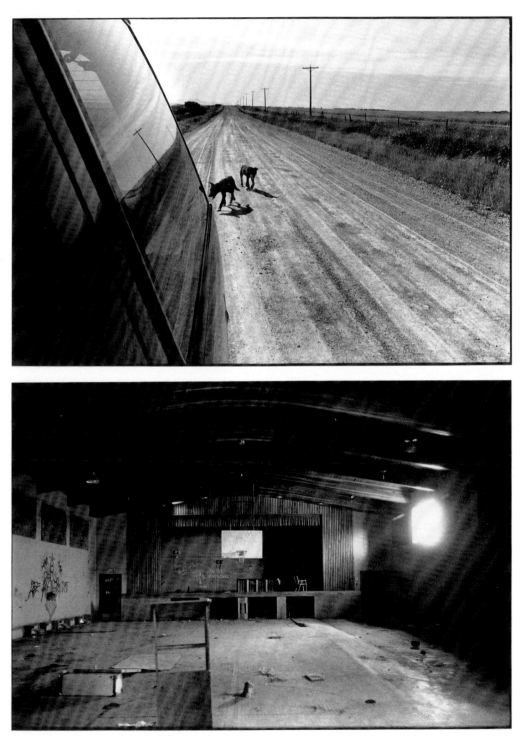

August 29, 2005

Late in the afternoon I drive up to Horace's house. He opens a drawer and pulls out the photograph I'd made of him just after he completed his first Sun Dance in 2000. "I was thirty-seven when you took that picture. With this ulcer I've lost fifty pounds since then," he informs me. I photograph him holding the picture.

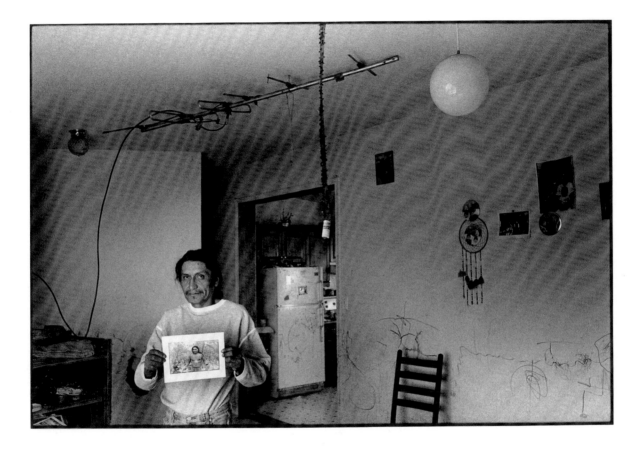

Horace tells me about his job in nearby Cardston, just beyond the southern tip of the reserve. He is working in a manufactured-home (trailer) plant, which produces a unique product that resembles a log cabin. A tiny smile compresses his lips. His head tips back, reflecting the sky in his dark eyes. "I'm lead hand now."

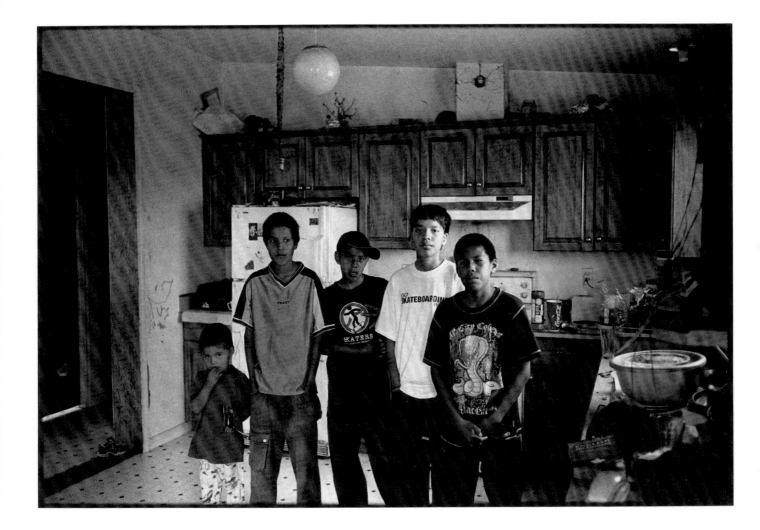

Acknowledgements

This book is dedicated to my grandparents, Frank and Margaret Webber and Joseph and Emma Cramer.

Thank you to the people of the Blood Reserve, who honoured me with their stories and their trust.

Thank you to my publishers, Sharon Fitzhenry and Charlene Dobmeier, editor, Meaghan Craven, and promotions director, Simone Lee, for their gifts of courage, energy, and good humour in making this book possible.

Thanks especially to the good Lord for watching over me on my journey.

About the Author

George Webber is the eldest of seven children born into a Catholic family in the coal-mining town of Drumheller, located in the badlands of southern Alberta. His boyhood environment left a powerful and lasting impression on him. At the age of five he began exploring the badlands for dinosaur bones, amassing a considerable collection. He still has a box of his favourites in the basement.

Growing up in Drumheller, George became attuned to the texture of the small prairie town, the light streaming through the stained glass in St. Anthony's Church, the bags of ribbon-knotted treats and the creaky, well-worn floor of the People's Bakery. Most of all, he remembers the people, the farmers, townsfolk, Hutterites, and First Nations people who populated the streets of the town.

When he was seven, George's family moved a little to the west and south to the fast-growing city of Calgary. He had left the most formative part of his childhood behind. Twenty years later he went back to the badlands, this time with his shiny new Canon camera. Since that time, over a quarter of a century ago, he has photographed the people, small towns, and landscape of the prairie west, ceaselessly.

Once, when asked why he took so many pictures of the prairies, he said, "People sometimes think photographs arrest change, preserve a moment. This is only partly true. More often, they remind us that what we think is constant, what we think we know, is never really that way at all."

George's fascination with what he saw as a boy keeps him going back with his camera to see and to try to understand the significance of the things that formed him. His work is firmly grounded in the documentary tradition. Of that tradition, he has written, "Documentary photographers have always sought out people and places with important, true stories to tell. They need stories that will provide them with a sense of wonder, stories that might help them to learn courage and compassion, stories that will affirm and connect them to life."

Nearly all of the photographs George has taken over the past twenty-five years have been taken within one or two day's drive from his home in northwest Calgary. His award-winning

photographs have been published in numerous books and magazines. They can be found in major Canadian and international museum collections. He was inducted into the Royal Canadian Academy of Arts in 1999. In 2005, George was the only North American photographer to receive an award at the International Documentary Photo Awards in Seoul, South Korea. This award was established to recognize excellence in the field of documentary journalism.

George's previous book, *A World Within: An Intimate Portrait of the Little Bow Hutterite Colony*, was published by Fifth House in 2005. He lives in Calgary where he works as a freelance photographer and photography instructor at the Southern Alberta Institute of Technology.

About the Photographs Note: page numbers are listed in brackets

The Seven Directions

[39] Sweat lodge, near Standoff, 1998

[40] Trees along the Old Man River, 1998

[41] Truck, 1998

[43, top] Frank Smallface, his wife, Randa Weaselhead, and their daughter, Kayleen Smallface, in their living room, Standoff, 1999

[43, bottom] Memorial erected for Randa's daughter, Gina, who was killed in a car accident near Standoff, 1999

[44] St. Catherine's Cemetery, near Standoff, 1999

[45] St. Catherine's Cemetery, near Standoff, 1999

[46–47] Elizabeth Eagle Speaker at the funeral of her grandson, Roland Scout, St. Catherine's Cemetery, near Standoff, 1999

[48] St. Catherine's Cemetery, near Standoff, 1999

[49] St. Catherine's Cemetery, near Standoff, 1999

[50–51] Sunset, Blood Reserve, 2005

[52] Horse skull, near Standoff, 1999

[53] Sweat lodges, near Standoff, 1999

Gratitude to the Creator

[55, top] Before the harvest of the centre-pole tree at the Keith Chief Moon Sun Dance, 2000

[55, bottom] After the harvest of the centre-pole tree at the Keith Chief Moon Sun Dance, 2000

[56–57] Keith Chief Moon with scars, Keith Chief Moon Sun Dance, 2000

[59] Horace Shouting shortly before his first Sun Dance, 2000

[60–61] Horace Shouting after completing his first Sun Dance, 2000

[61] Horace Shouting after completing his first Sun Dance, 2000

[63] Remnant of sweat lodge, near Standoff, 2000

[65] Brush, 2000

[66] Chimney stack of demolished school, Levern, 2000

[66–67] Chief Mountain and gravel road, 2000

[68] Chief Mountain and trailer, 2000

[69] House with dog, 2000

[70, top] Interior of vandalized house, Standoff, 2000

[70, bottom] James Across the Mountain, Standoff, 2000

[71] Photographer's shadow in sweat lodge, near Standoff, 2000

Storm Clouds

[73] Cowboy with lasso, Kainai Days, Standoff, 2001

[74] Young Native dancers, Kainai Days, Standoff, 2001

[75] Native dancers, Kainai Days, Standoff, 2001

[76–77] Sharlee Weaselhead, barrel racer, Kainai Days, Standoff, 2001

[78] Tyler Little Bear, bull rider, Kainai Days, Standoff, 2001

[79] Bull riders warm up, Kainai Days, Standoff, 2001

[80] Kainai Days rodeo, Standoff, 2001

[82] Highway and storm, 2001

[83] Farmhouse and rainbow, 2001

[85] Standoff under storm clouds, 2001

[86] Basketball net, Standoff, 2001

[87] Sweat lodges and power pole, Levern, 2001

[88, top] Tree, 2001

[88, bottom] Tilting tree, 2001

[89] Sweat lodges, near Standoff, 2001

[90] The Buttes in spring, 2001

[90–91] Buttes and fence in spring, 2001

[93] Brush near the Belly River, Good Friday 2003

The Awareness of Thirst

[95] Cattle, near Standoff, 2005

[97] Stop sign and road, 2005

[99, top] Dogs near "Little Chicago," 2005

[99, bottom] St. Paul Residential School (built 1924), abandoned gymnasium, 2005

[101] Horace Shouting in his living room (holding a picture of himself after completing Sun Dance in 2000), 2005

[102] Boys in Horace Shouting's kitchen, 2005: (left to right) JT Eagle Child, grandson of Horace; Dallas Shouting, nephew of Horace; Dwight First Charger, son of Lenora Scout; Thorn Shouting, son of Horace; Ryan Shouting, nephew of Horace

Technical Note

Camera: Leica M6
Lenses: 35 mm and 50 mm
Film: Ilford HP5
Reproduction prints: Ilford Multigrade FB and RC paper
Exhibition prints: Ilford Multigrade FB paper

All photographs were hand developed and printed by the photographer. The narrow black line at the edge of each image is from the negative rebate, the clear portion of a negative that falls just beyond the edge of the picture. Inclusion of this black line indicates that the photograph has been printed exactly as it was shot, with no cropping.

About Fifth House

Fifth House Publishers, a Fitzhenry & Whiteside company, is a proudly western- Canadian press. Our publishing specialty is non-fiction as we believe that every community must possess a positive understanding of its worth and place if it is to remain vital and progressive. Fifth House is committed to "bringing the West to the rest" by publishing approximately twenty books a year about the land and people who make this region unique. Our books are selected for their quality and contribution to the understanding of western-Canadian (and Canadian) history, culture, and environment.